Jamaica through my eyes

Lois Samuels Ingledew

MACMILLAN
CARIBBEAN

Macmillan Education
Between Towns Road, Oxford OX4 3PP
A division of Macmillan Publishers Limited
Companies and representatives throughout the world

www.macmillan-caribbean.com

ISBN 1-4050-1022-3

First published 2005

Designed by Gary Fielder at AC Design
Cover design by Gary Fielder at AC Design
Cover illustration/photograph by Mark Ingledew
Map by David Atkinson at Handmademaps.com

The author and publishers would like to thank the following
for permission to reproduce their photographs.

Acknowledgements

The author and publishers would like to thank the following for
permission to reproduce their photographs:

Jean Baptiste Mondino p 2; Vernon Jolly Inc and
Marc Baptiste p 4; Icon International and Walter Chin,
German Vogue pp 4, 5; Michele Filomeno Agency and
Peter Lindbergh p 5 (image titled Black Gang/South Side
taken in London, 1996 for The Face), p 6 (image titled
Black Couture/Paris, La Couture taken for Vogue Italia in
1997, Atelier Astre, Paris); Essence Magazine and JGK Inc
on behalf of Ruven Afanador pp 4, 92; LMH Publishing p 92;
Robert Trachtenberg p 93; Gerry O Halloran p 93;
Norine Perrault p 96.

If any copyright holders have been omitted, please contact the
publishers who will make the necessary arrangements at the first
opportunity.

Printed and bound in Thailand

2009 2008 2007 2006 2005
10 9 8 7 6 5 4 3 2 1

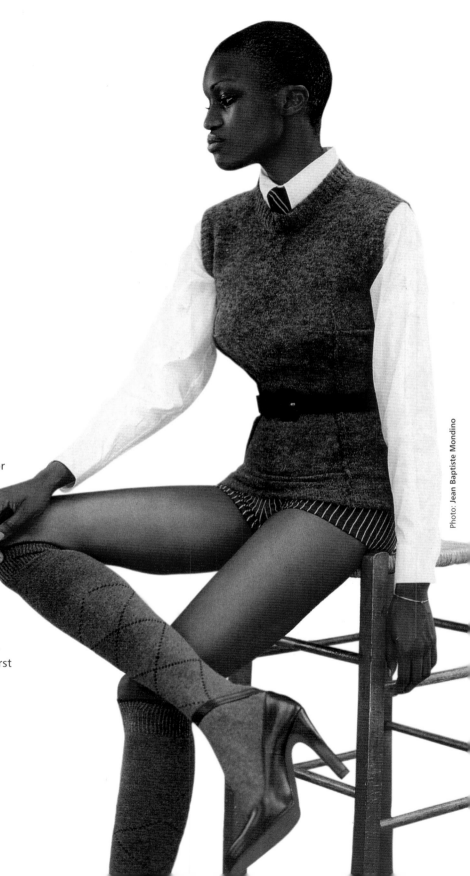

Photo: Jean Baptiste Mondino

Dedication

To my husband, Mark Ingledew, for his love and endless support and our son Malo Josiah Ingledew, and for my friends in Jamaica who have given a part of themselves towards this book.

The Other Side of the Camera

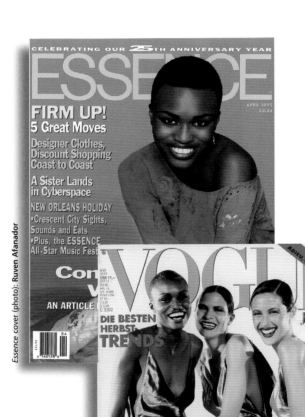

Essence cover (photo): Ruven Afanador

Vogue cover (photo): Walter Chin

I bought my first camera in 1997 and doing a book about Jamaica immediately became a dream project. Instead of being the one in front of the camera as a model, posing for magazines from *Essence* to *Vogue*, or doing campaigns for Calvin Klein or Banana Republic, I wanted to be the one behind the camera, capturing the soul and beauty of a nation.

Photo: Marc Baptiste

"I wanted to be the one behind the camera, capturing the soul and beauty of a nation"

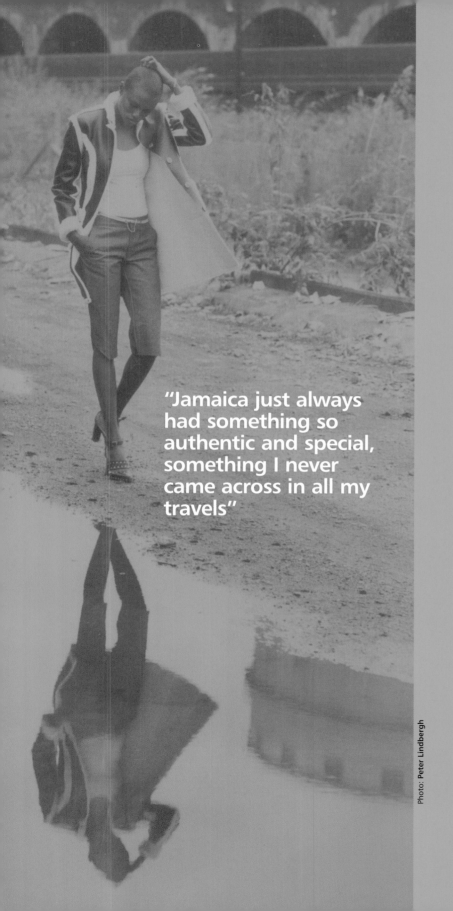

"Jamaica just always had something so authentic and special, something I never came across in all my travels"

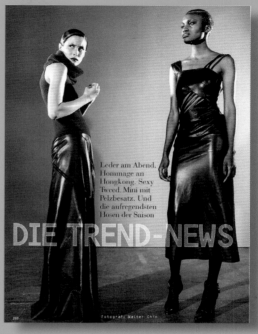

Leder am Abend. Hommage an Hongkong. Sexy Tweed. Mini mit Pelzbesatz. Und die aufregendsten Hosen der Saison

DIE TREND-NEWS

Fotograf: Walter Chin

For me, Jamaica just always has something so authentic and special, something I never came across in all my travels. I called different cities 'home', from Paris to Milan. New York to London, but each time I returned to my real home I loved it so much more than I ever did when I was a young girl, growing up in the country areas of St Paul's, Manchester or the little thriving town of Santa Cruz, St Elizabeth.

My passion for photography led me to seize every opportunity to drive around country roads and find little secret spots for snapping pictures, whenever I was home from my busy schedule.

I saw how much Jamaica was changing: there was so much influence from other countries. Some things were great, others I found not so great. Seeing all those fast food restaurants, the same from New York to Florida, watching the same television programmes, hearing the same slang and twang made me feel at times I might be anywhere other than Jamaica. It was great to see the standard of living rise and the majority of people living comfortably in more beautiful homes, having better jobs, driving nicer cars but I somehow wanted to capture the old Jamaica – not to be misunderstood, just fewer buildings and less fancy smancy!

I took most of my images in the parish of St Elizabeth, since that is where I spent most of my youth. I liked to roam around in Top Hill and the surrounding area of Southfield, where both my parents came from. Much farming is done in that area and there is always a sweet smell of smoke and scallions, which, surprisingly, I smell when I look at some of those pictures – *the wattle and daub house* (pages 46-47) or *Rat and Cousin Granville* (pages 26-27). And there is such a great community spirit there. In that area everybody knows everyone. Most of the men there are farmers and they probably gather at the shops after work or at the lunch hour and have a cold red stripe beer, with a laugh, and on some evenings they may play a game of dominoes.

"I wanted to capture the old Jamaica – not to be misunderstood, just fewer buildings and less fancy smancy!"

But for hundreds of years my relatives have lived in Ridge on the other side of Tophill. My *Grandma Avis* (pages 16-17), who went to London in the early 50s to work as a kitchen helper, returned after thirty years and built her house on the same property - something most West Indian immigrants do – because she didn't want to get too old and die in London. She is now 83 and so happy and content, living on her little farm, where she gets help rearing some goats and planting scallions and carrots.

Like my Grandma, *Ms Rose* (pages 18-19) spent many years in London in the 50s and 60s. Now she lives close by Grandma's house, in Ridge. In the photograph you may notice how red the soil is in that area. It is very rich in aluminium and not too far from there is Alpart, an aluminium bauxite company. I find the image of Ms Rose ironic in that her grandchild holds the stick, which signifies the future, and she holds the white doll and it's as if she's becoming a baby again. When I was a child, one of my first memories of my Grandma Avis was Sally, a white doll with blonde hair and blue eyes that my sister and I received from her one Christmas. I remember how beautiful we thought she was and now, looking back, it is funny there were no black dolls at that time. Now I think it is great that little black or white girls can have little black or white dolls if they want.

Closer to Santa Cruz, I remember taking a drive one Sunday morning and I stopped at *Levy's shop in Leeds* (pages 20-21). It is the beginning of that long street that I would have to take every morning on the big country bus when I was a student at Hampton School for girls in Malvern. Anyway, his shop was open early, which meant good business for him if you hadn't picked up little things on Saturday in Santa Cruz. Because on Sundays most businesses are closed and he sold the basic necessities with the Sunday morning paper. We chatted for a bit before I asked to take their picture and they were cool, so everyone was happy.

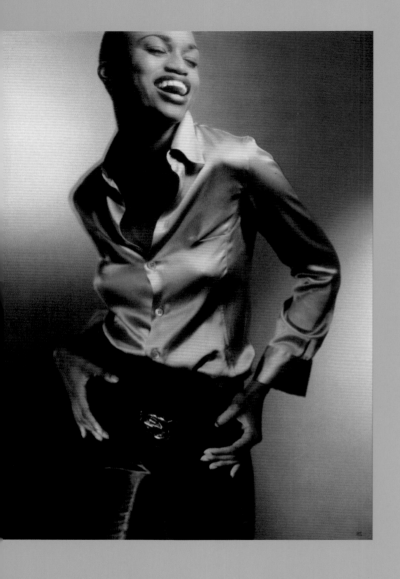

The whole south coast area is becoming a popular tourist destination for the easy-going tourist looking for an irie Jamaican get-away, where it feels local, calm and laid back, without the hustle and bustle. There is *Treasure Beach* (pages 60-61), which is just a treasure – no, there are no pirate stories or any golden chests to be found . . . but I enjoy going there and I visit it each time I am at home, even to get my feet wet.

Not too far from Treasure Beach is *Lovers' Leap*, one of the island's beauty spots. It is perched 1,750 feet on a cliff above the Caribbean Sea. The story of Lovers' Leap is that there were two slaves who really loved each other and the slave master decided that they shouldn't be seeing each other any more, so he was going to separate them. They decided to jump and die rather than not be together.

"They decided to jump and die rather than not be together"

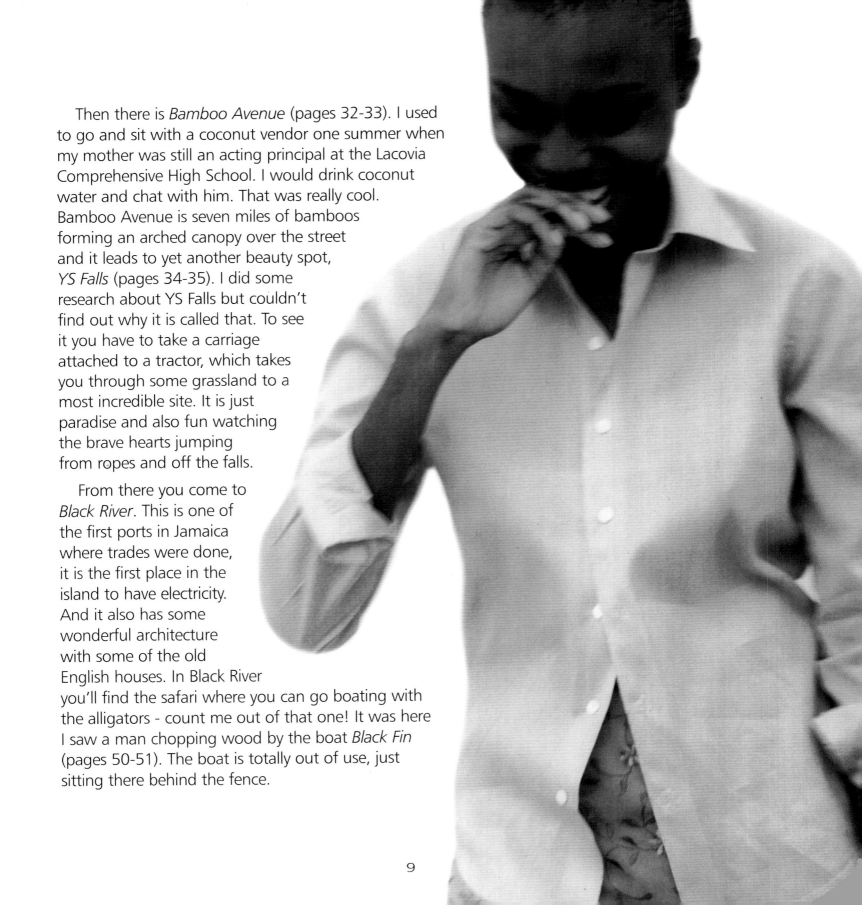

Then there is *Bamboo Avenue* (pages 32-33). I used to go and sit with a coconut vendor one summer when my mother was still an acting principal at the Lacovia Comprehensive High School. I would drink coconut water and chat with him. That was really cool. Bamboo Avenue is seven miles of bamboos forming an arched canopy over the street and it leads to yet another beauty spot, *YS Falls* (pages 34-35). I did some research about YS Falls but couldn't find out why it is called that. To see it you have to take a carriage attached to a tractor, which takes you through some grassland to a most incredible site. It is just paradise and also fun watching the brave hearts jumping from ropes and off the falls.

From there you come to *Black River*. This is one of the first ports in Jamaica where trades were done, it is the first place in the island to have electricity. And it also has some wonderful architecture with some of the old English houses. In Black River you'll find the safari where you can go boating with the alligators - count me out of that one! It was here I saw a man chopping wood by the boat *Black Fin* (pages 50-51). The boat is totally out of use, just sitting there behind the fence.

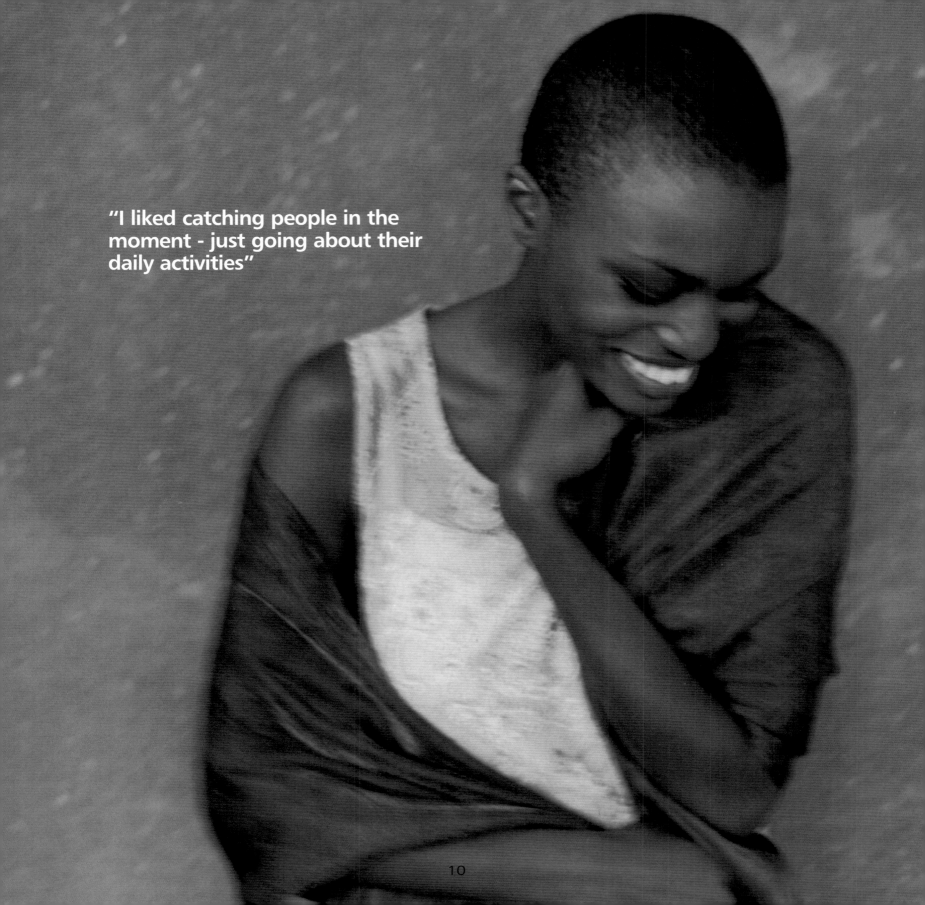

"I liked catching people in the moment - just going about their daily activities"

I explored Port Antonio, Negril, the hills of St Mary, Kingston City and other little villages around the island.

And there were the beaches: Hellshire Beach and Long Bay Beach and rivers which seemed to be enjoyed mostly by the youngsters. It seems ironic to me now, looking back, that we never went to the beach when we were kids. To see the beach was a big event and to walk on it was even bigger! Just don't bring sand in the car . . . ! I have just one beautiful memory of a day when the family went for a picnic on the beach. I think it happened only once, but I never forgot it - and there are the pictures to prove it. But I guess my parents rarely took me to the beach because neither of them could swim - a norm in most island homes.

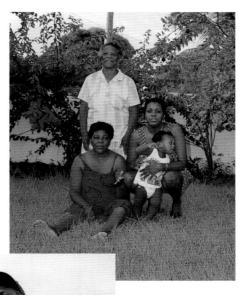

As I went about with my camera, I liked catching people in the moment - just going about their daily activities, like *coffee shop meeting* (pages 56-57), *lady on the go* (pages 58-59), *bus stop* (pages 80-81) and *take me to school* (pages 72-73). I liked feeling their personalities like the people in Mr Levy's shop in Leeds, *3 stars* (pages 66-67) and *face-ty girl* (page 86). And it was great to get my parents - my dad on his farm and mother at home with my sister, nephew and Grandma Avis - since they play such an important role in who I am today. Overall, I just wanted to capture the beauty of the island and its people.

Jamaica has its beautiful beaches, its pulsating reggae music, beautiful people - not to forget its great food! But still, the island is a gold-mine . . . there is so much more to discover. So I give you some of my beautiful Jamaica - until next time.

Lois

11

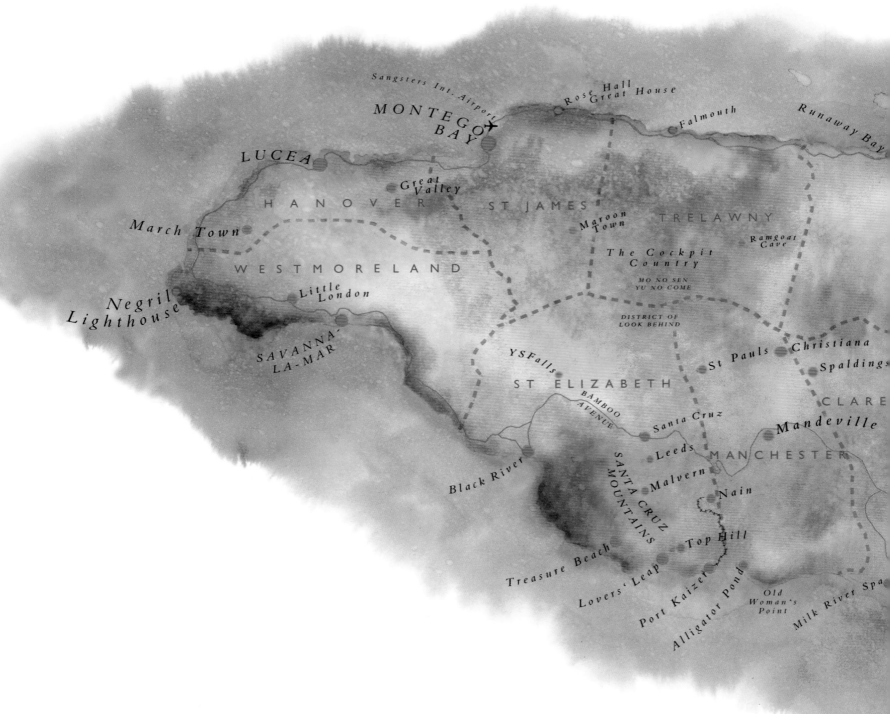

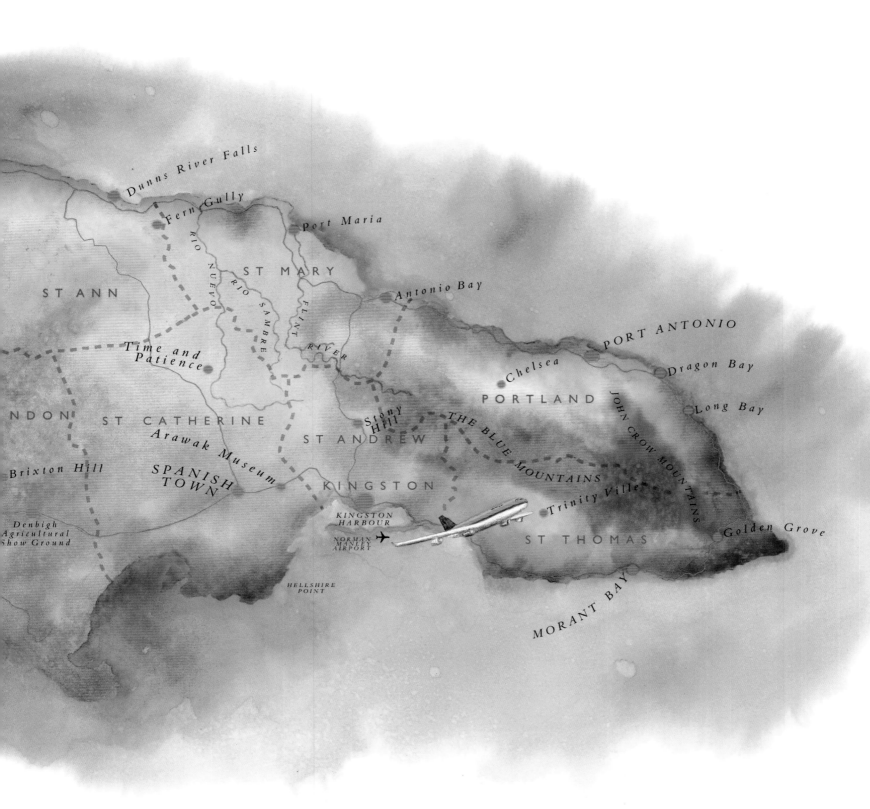

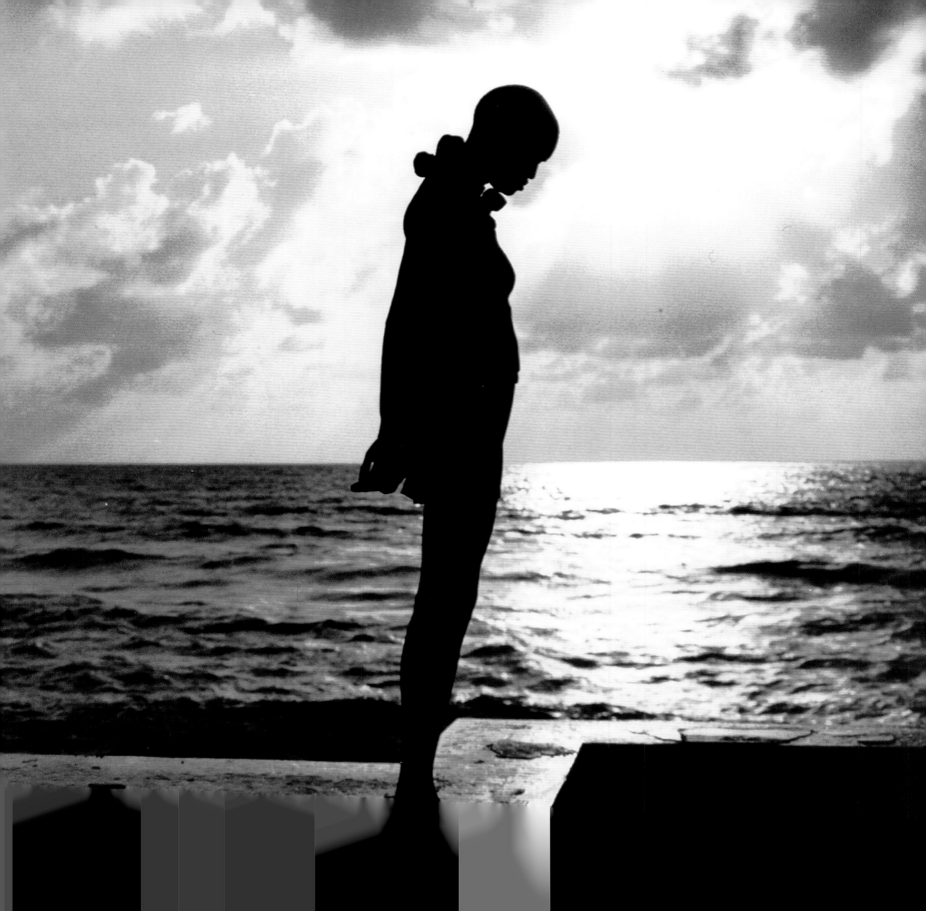

If

If I hadn't grown up on this land,

If I hadn't had two dogs, Sheeba and Fluffy,

If I hadn't played hopscotch on the dirt ground with my sister,

If I hadn't drunk Red Stripe and sung reggae with Bob Marley,

then. . .

I wouldn't be me.

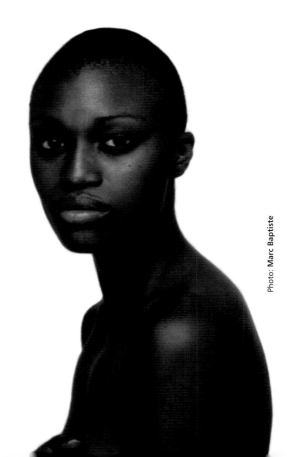

Photo: Marc Baptiste

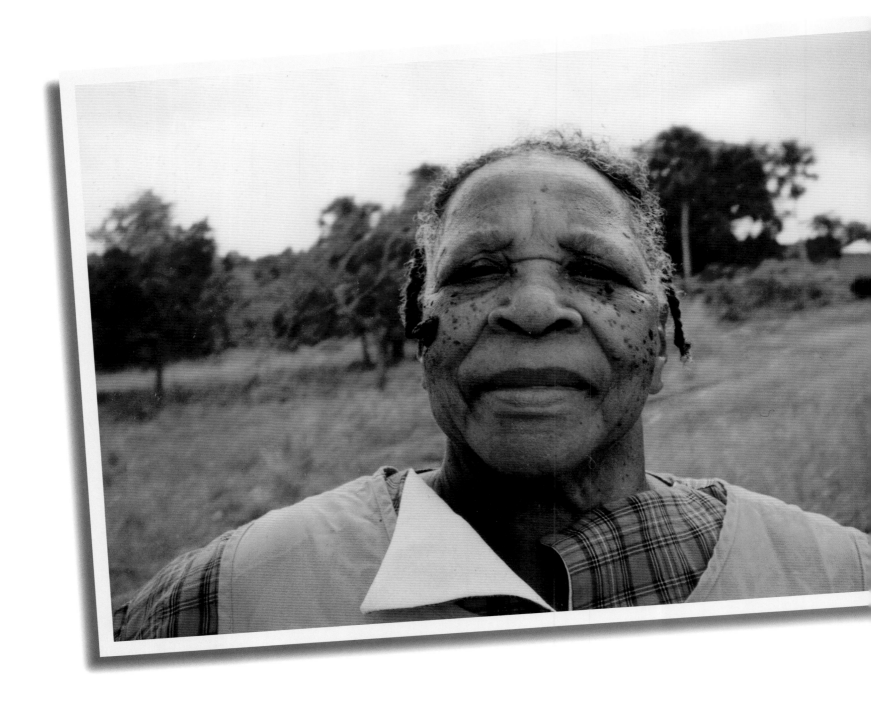

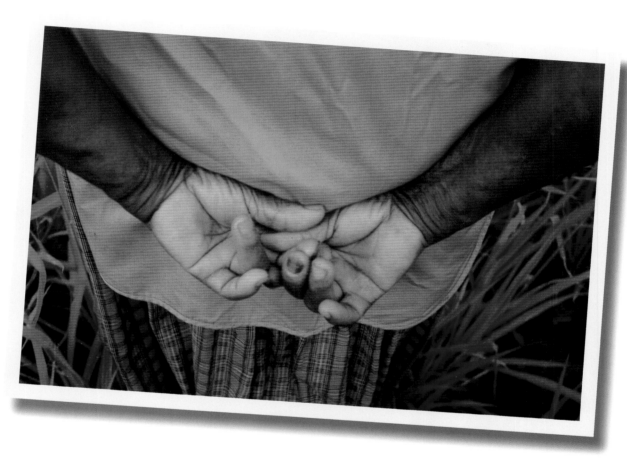

Grandma Avis, Top Hill.

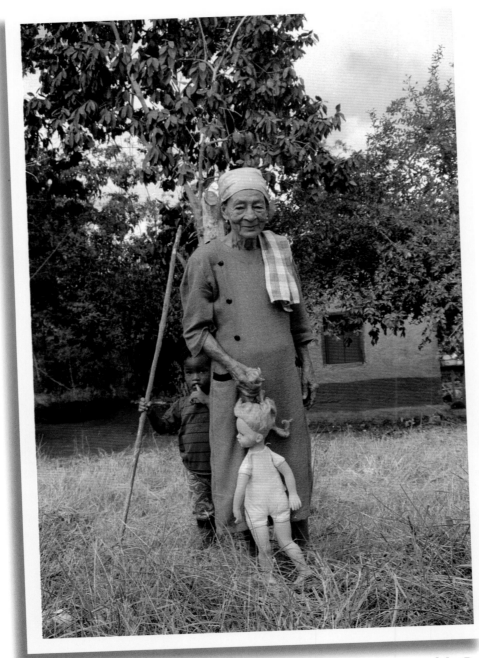

Ms Rose.

Driving up the red dirt road to Ridge,
there stood Ms Rose.
Ms Rose with doll in hand,
great grandchild with long strong rod.
I just had to stop and snap.

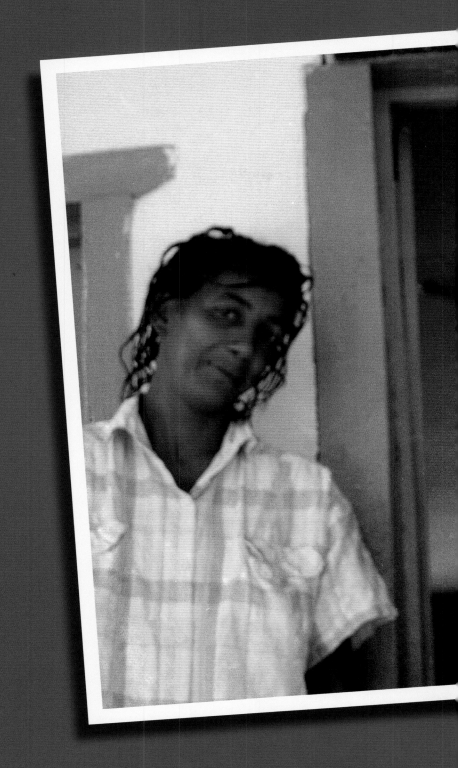

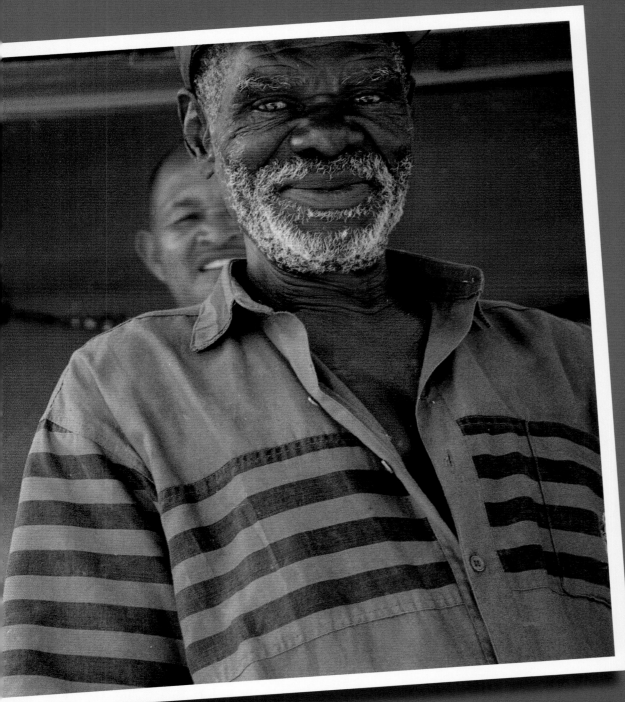

Levy's shop, Leeds.

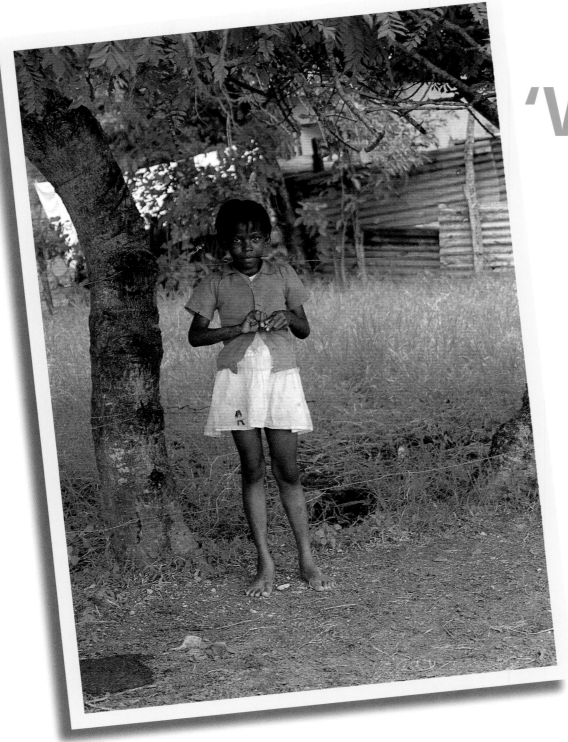

'What is

your name?'

Around the corner from where she stands is a pond.

When I wore her years I never passed this pond without looking at it on the journey to and from my Dad's house on the hills of St Paul's, in his small green car.

On this pasture a pond came whenever the rains fell heavily and settled for a few days. I loved to look at the black and red cows as they lazily grazed on the grassland, swishing their tails from left to right in the company of the tall white skinny birds that picked their pestilences away. The same birds who in the early mornings and late evenings transformed into beautiful white petals as they perched on the branches of the trees behind the pond.

She asks me, 'What is your name?'

I tell her.

She says, 'What do you want?'

'To take a picture,' I say. 'What is your name?' I ask.

She never says, only that she is going to see her pig. She walks towards the pond to look for her pig.

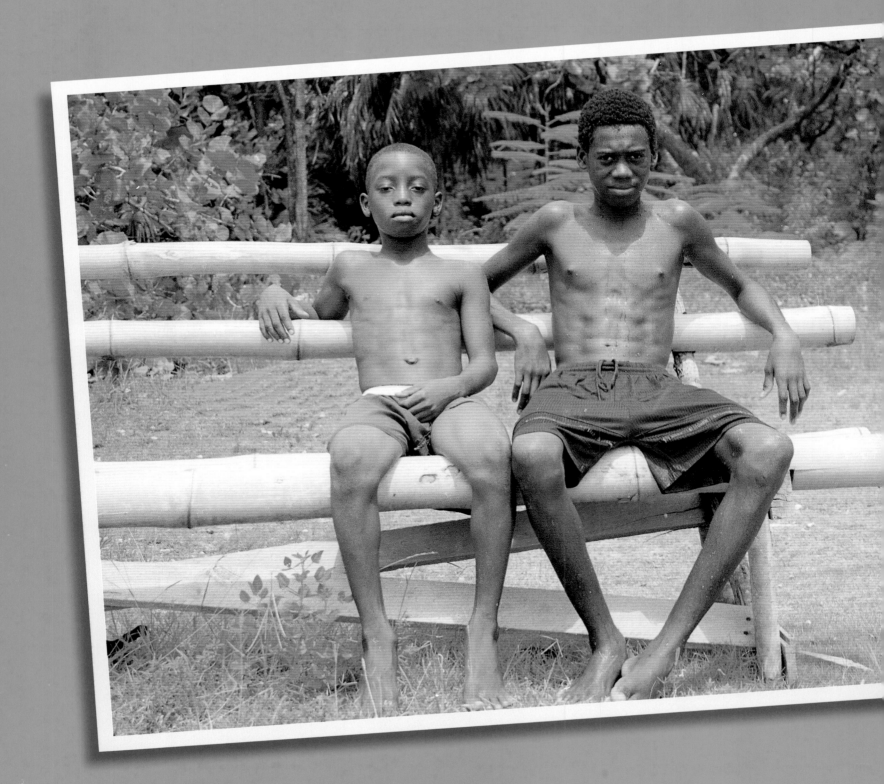

Rambo and friend, cliff jumpers at Three Dives Cliff Bar, Negrils, West End. Kids jump off the cliffs into the water.

It's not for money, it's just for fun. They jump off, feet first with a huge splash, and they go back up, and they jump and they go back up!

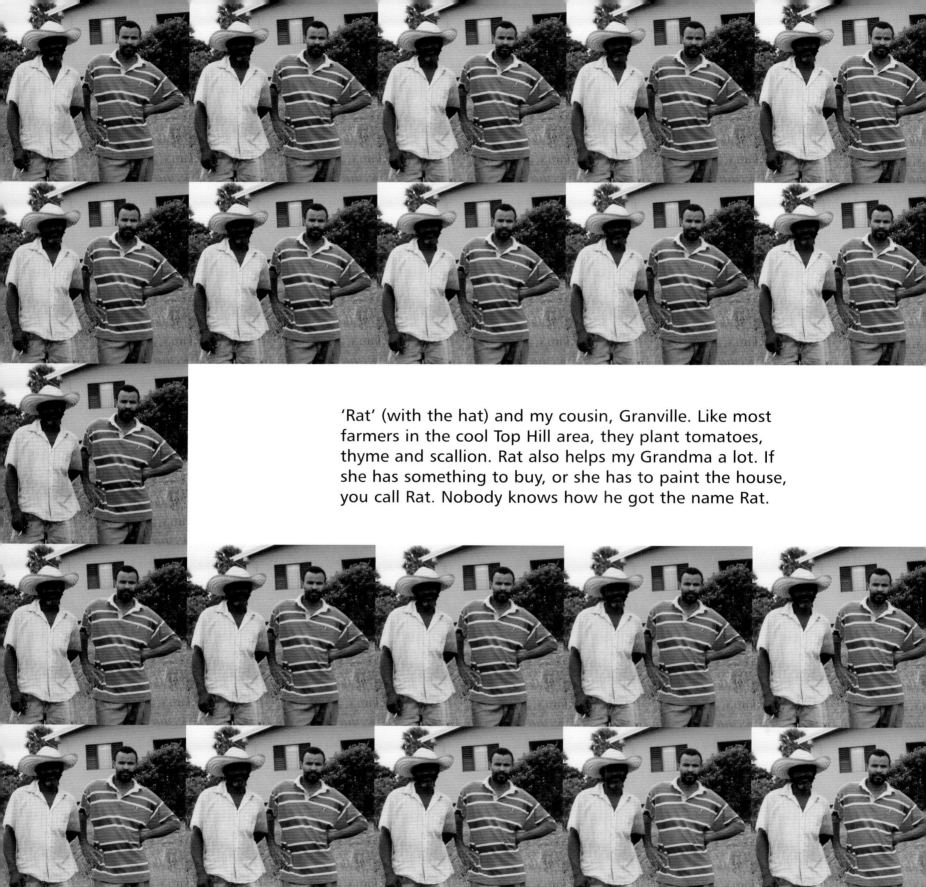

'Rat' (with the hat) and my cousin, Granville. Like most farmers in the cool Top Hill area, they plant tomatoes, thyme and scallion. Rat also helps my Grandma a lot. If she has something to buy, or she has to paint the house, you call Rat. Nobody knows how he got the name Rat.

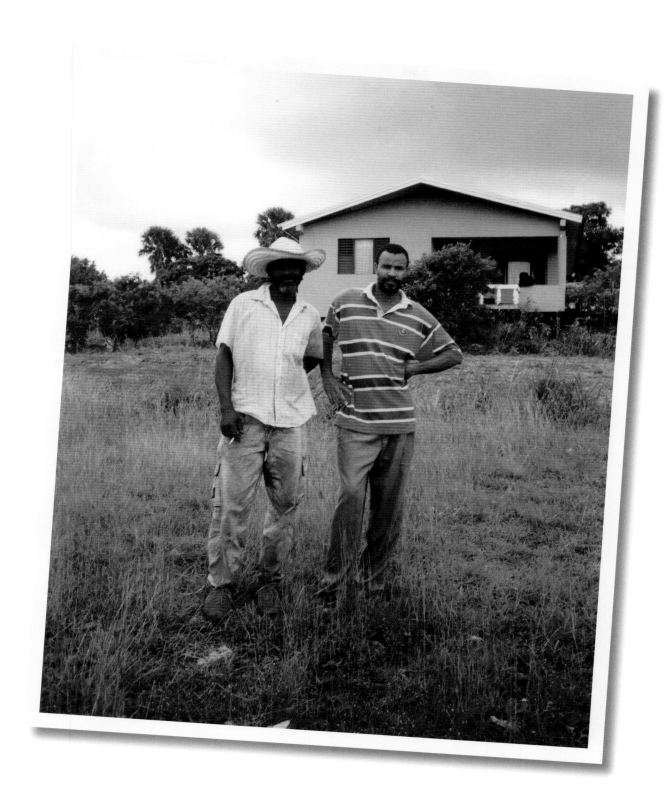

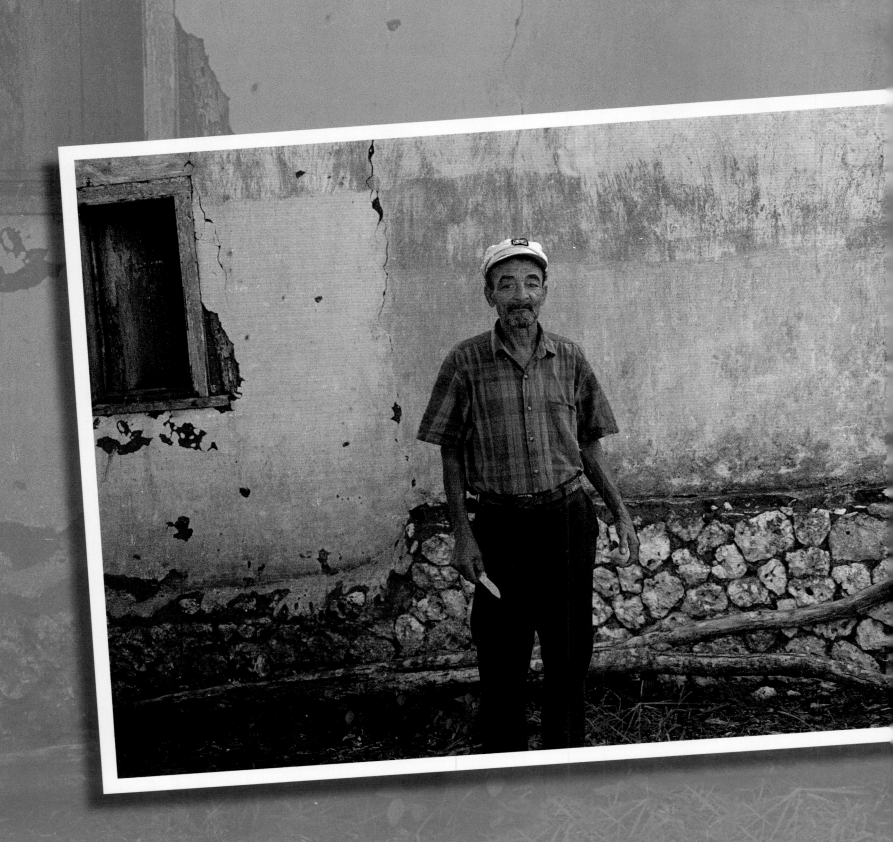

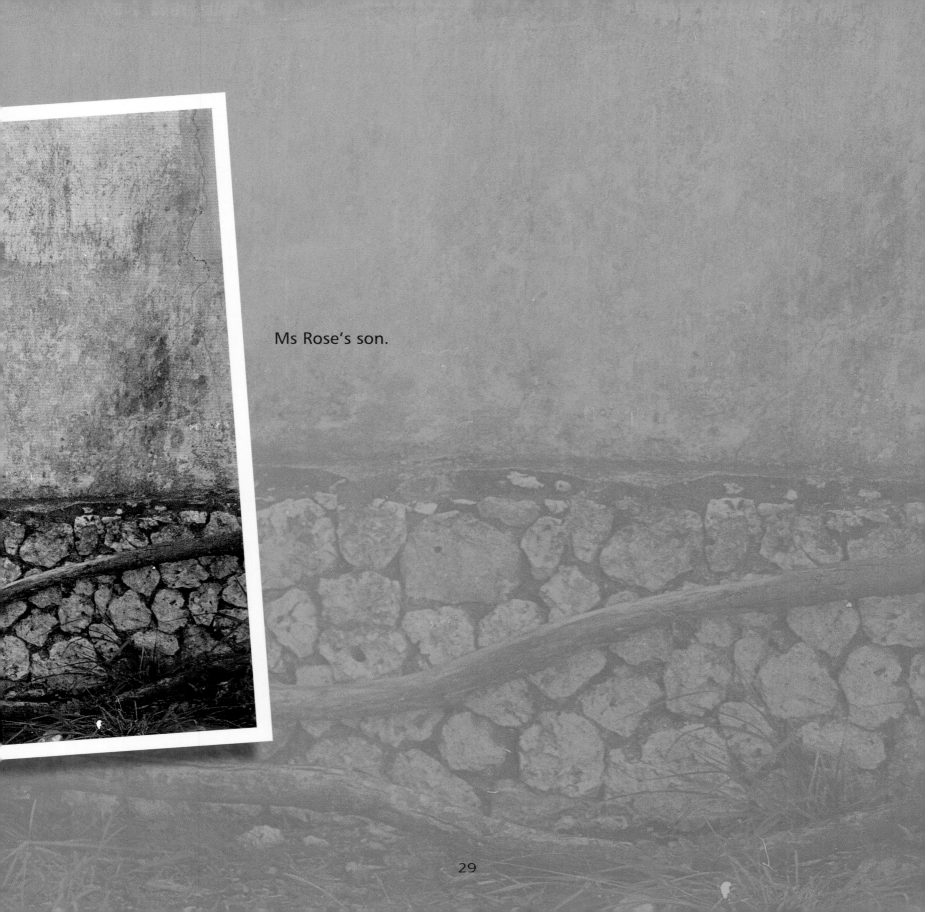

Ms Rose's son.

This Rastaman is a coconut and sugar cane vendor on the main road in the parish of Clarendon. I would stop by on my long drive from Kingston to St Elizabeth for some refreshing coconut water.

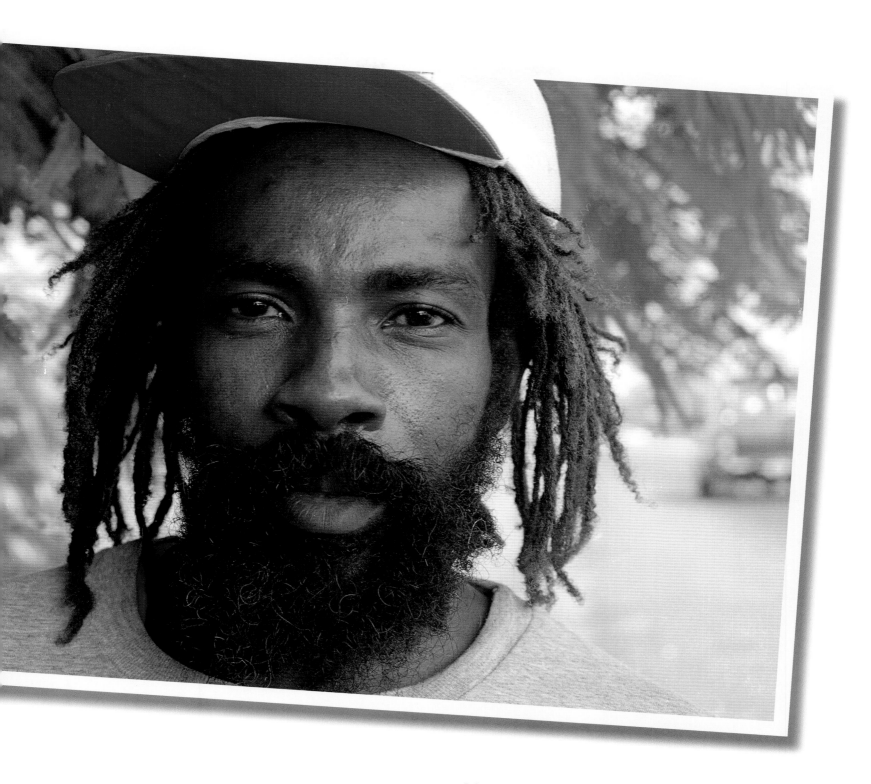

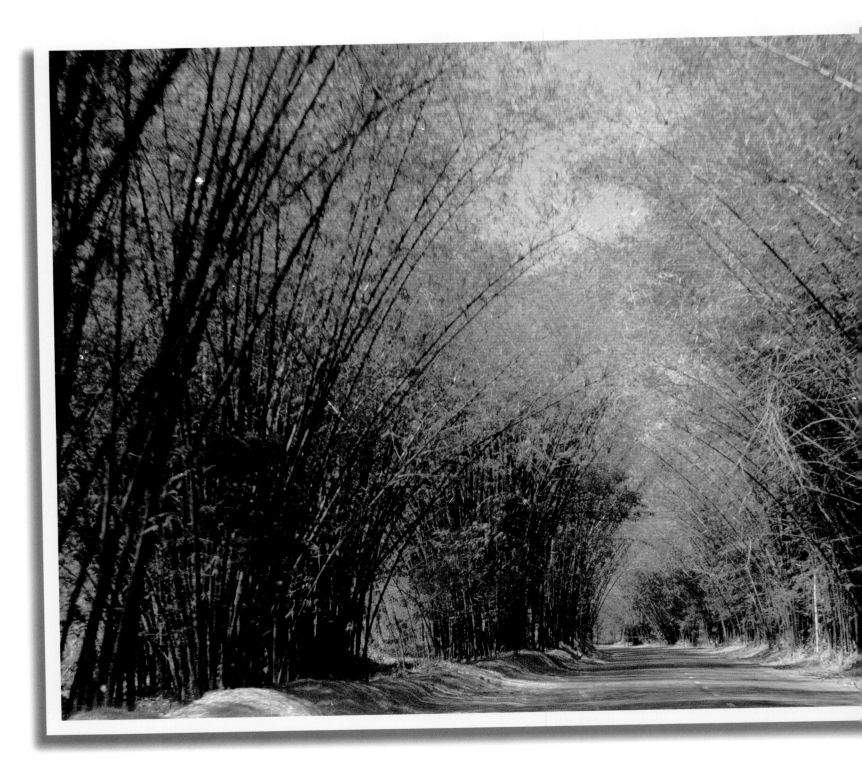

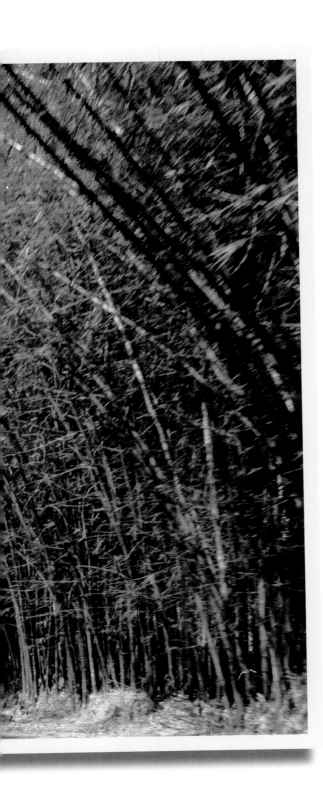

Bamboo Avenue, St Elizabeth.

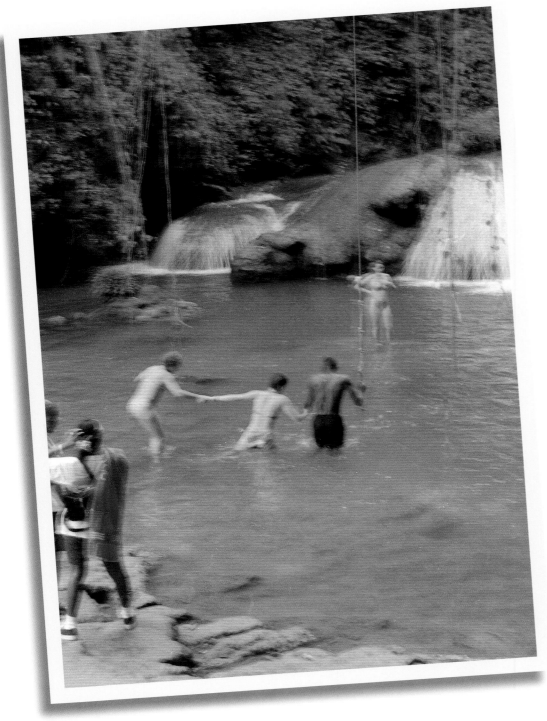

YS Falls, St Elizabeth.

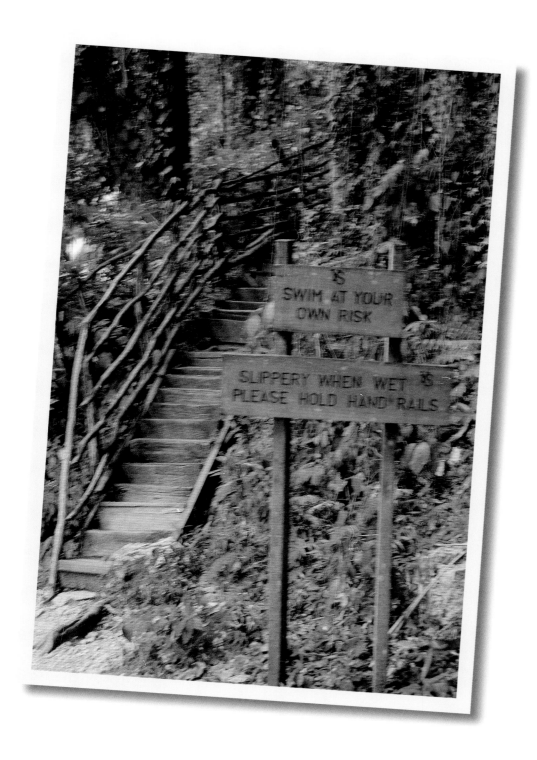

Walking into
the shadows
doesn't mean
you're walking
into darkness.

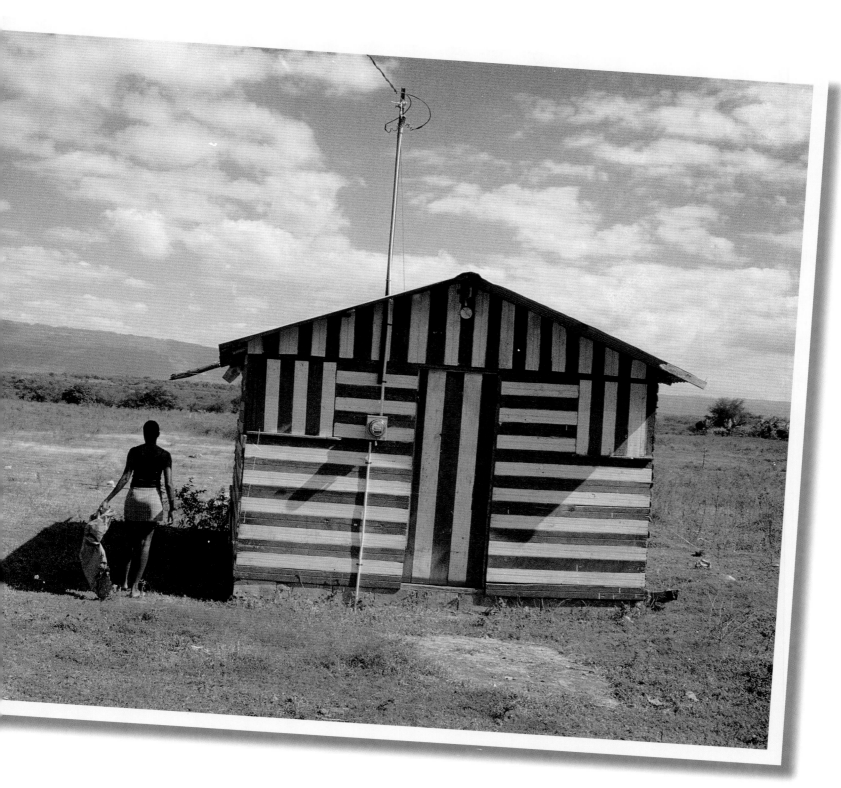

On a sunny day at Port Henderson beach,
St Catherine. Children come out to play.

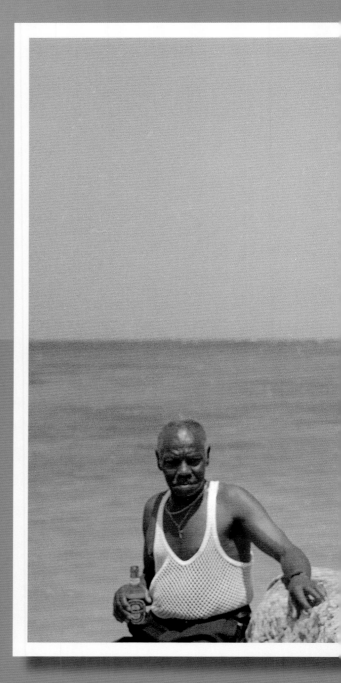

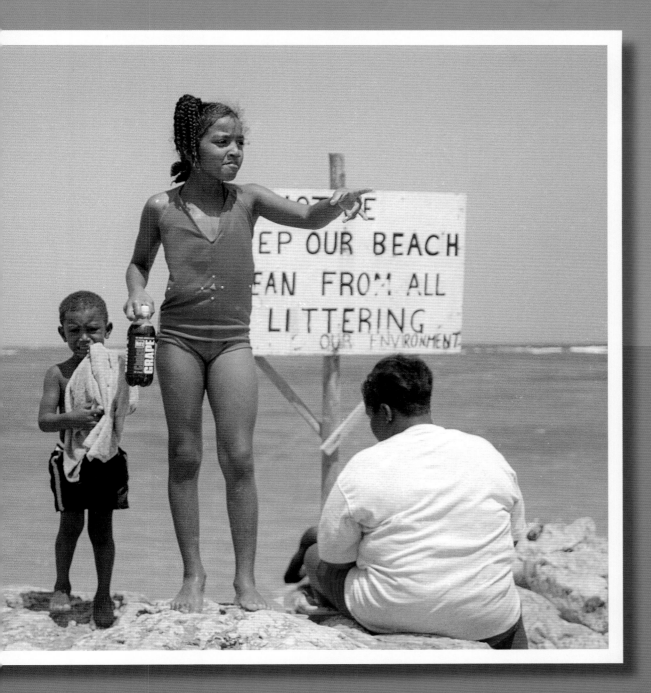

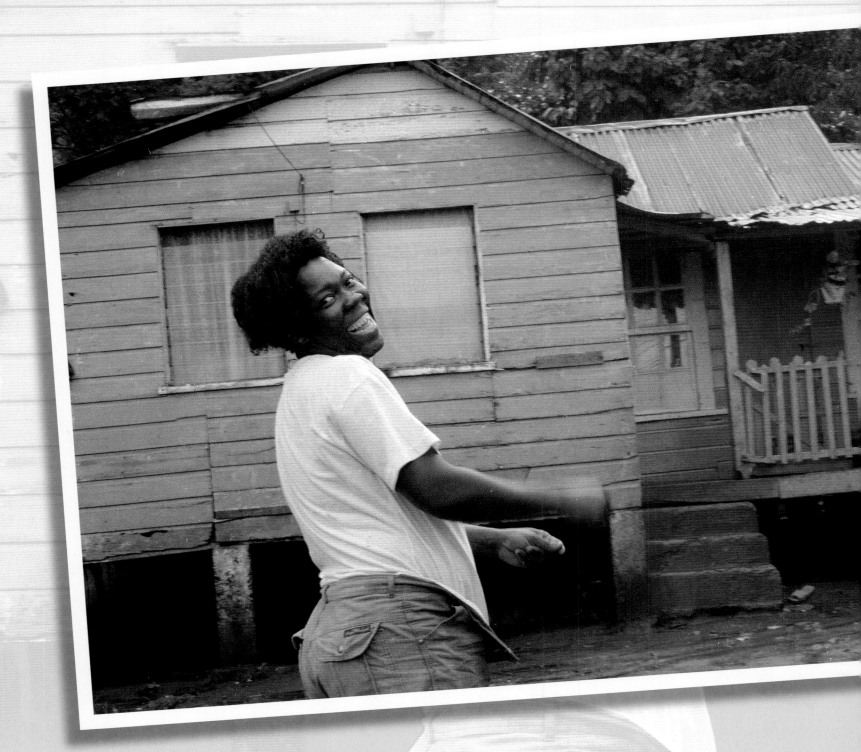

Lady of Port Antonio smiles from
the gates to her pink haven.

41

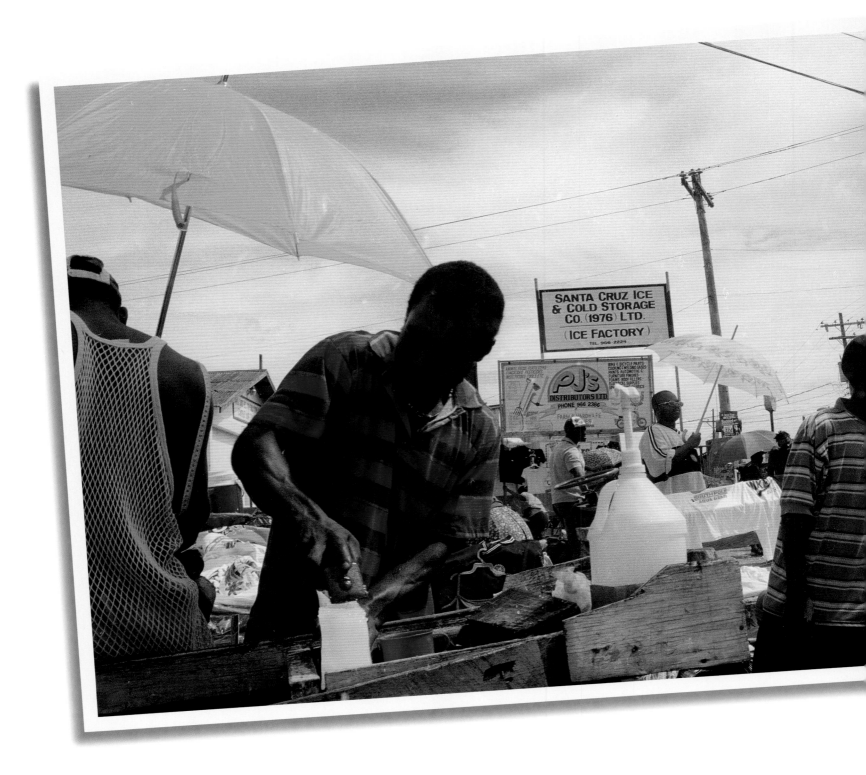

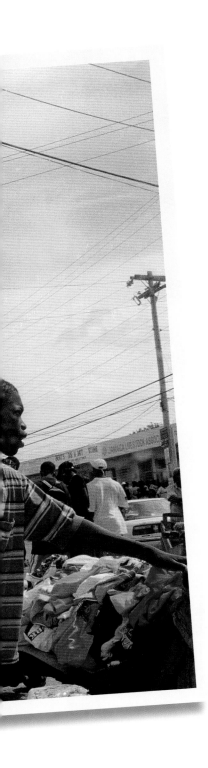

Sky juice man scraping ice in hot Santa Cruz Saturday morning market.

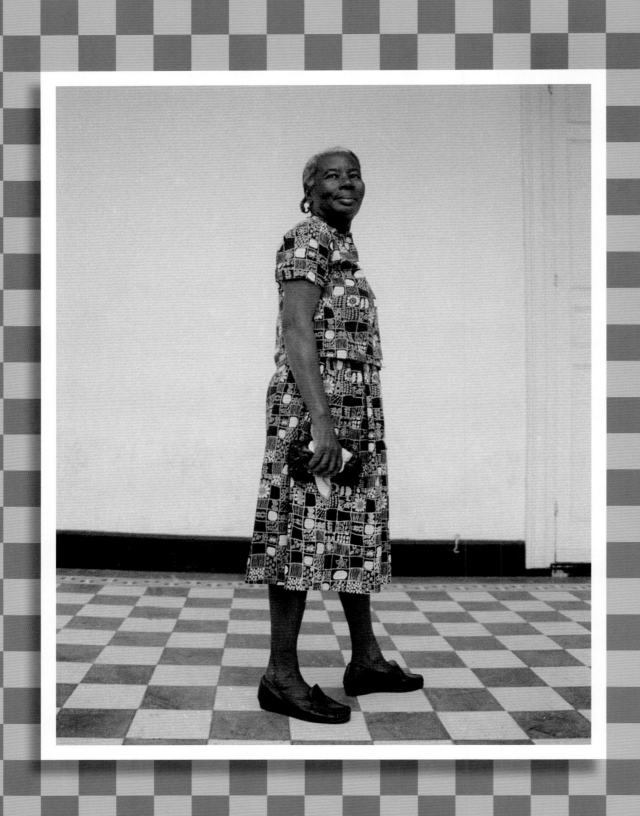

'We are the people who carried a nation.'

I met the lady on page 44 when I was
doing signings for my earlier book at
Devon House in Kingston. I just had to
get her standing on that floor.

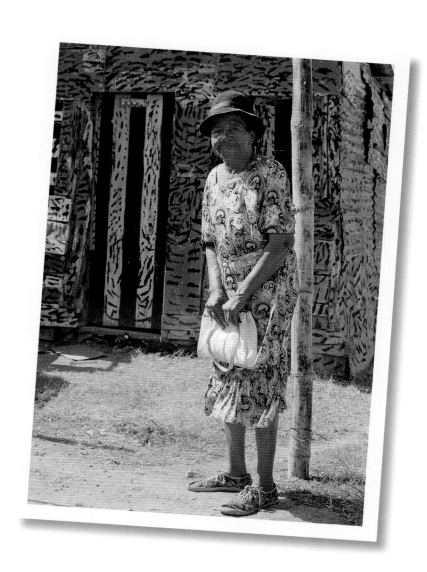

Lady at wooden shop.

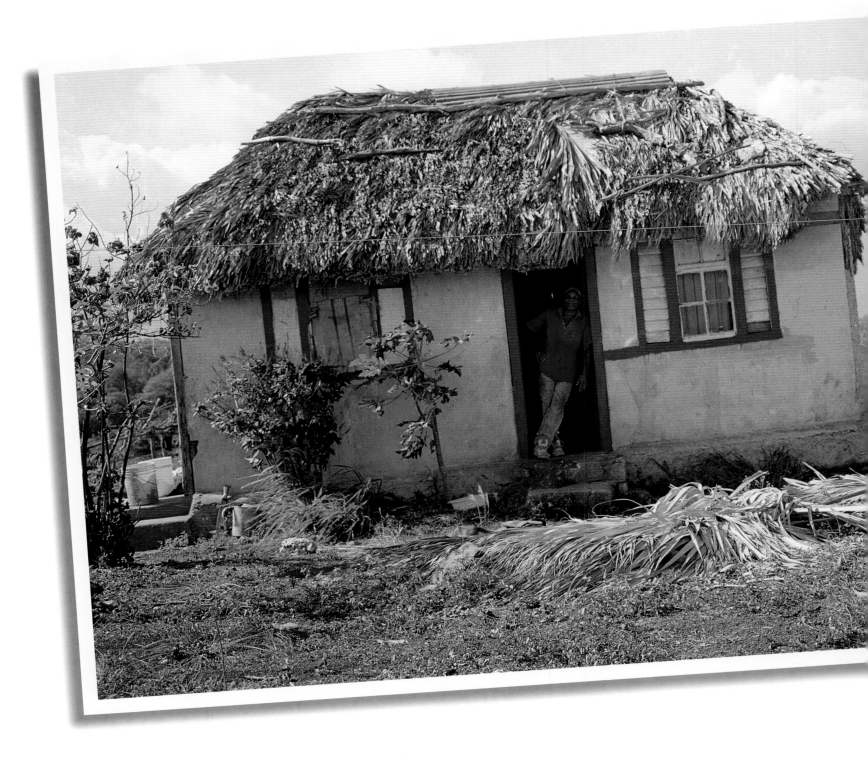

your eyes do not see

through my mud and stone

your eyes do not see through my leaves

 that tears flow

we of the lands giggle in the puddle

dance when the mango jiggles

and the corns sway in the winds

These wattle and daub houses are so strong, they withstand all the hurricanes. This one is close to one hundred years old.

It was early in the morning and they were playing dominoes. Most Sunday mornings are about going to church, because Jamaica is a very religious country . . . not for these guys.

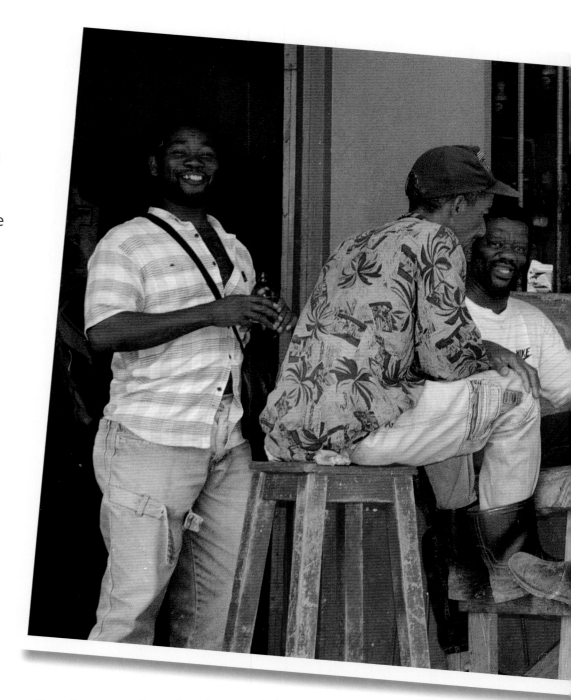

Sunday morning domino match.

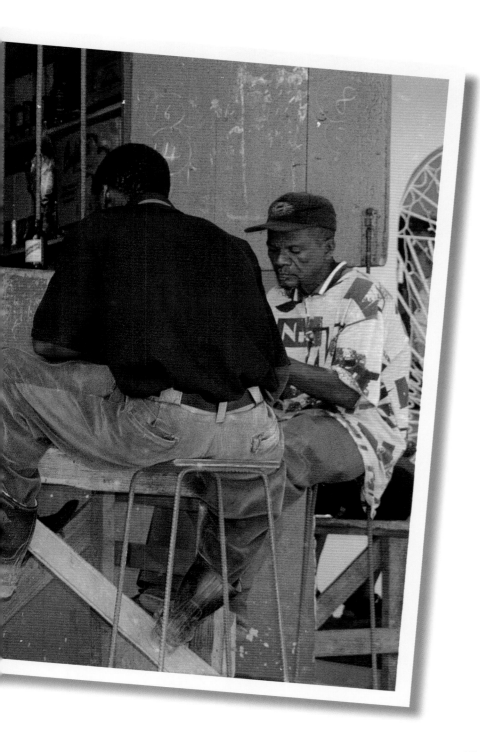

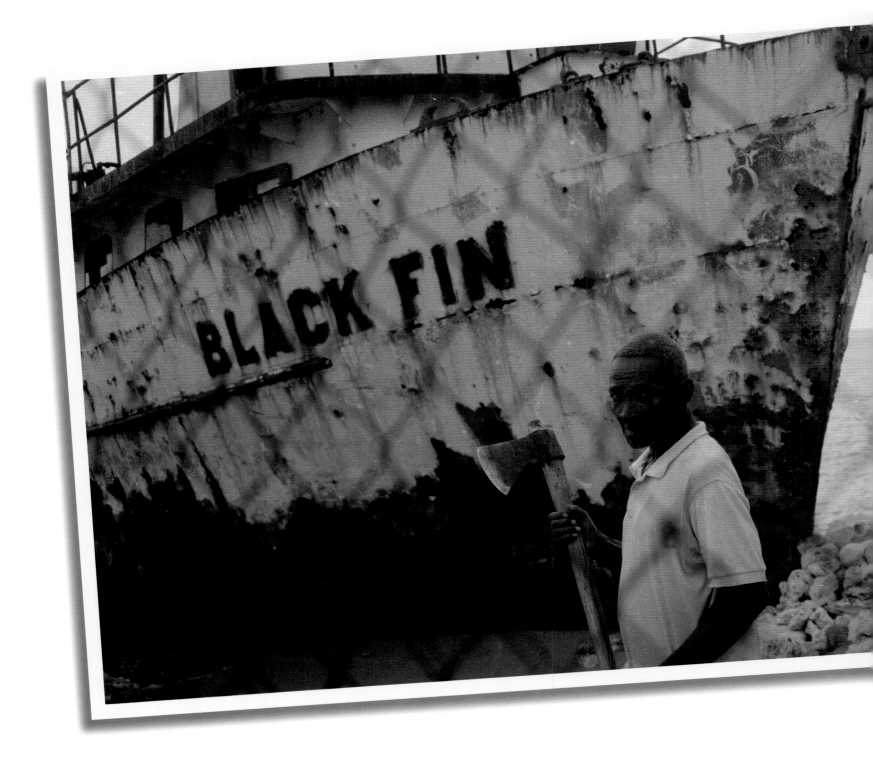

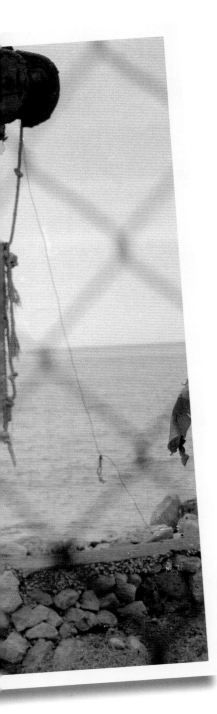

Man chopping wood by the water in Black River.

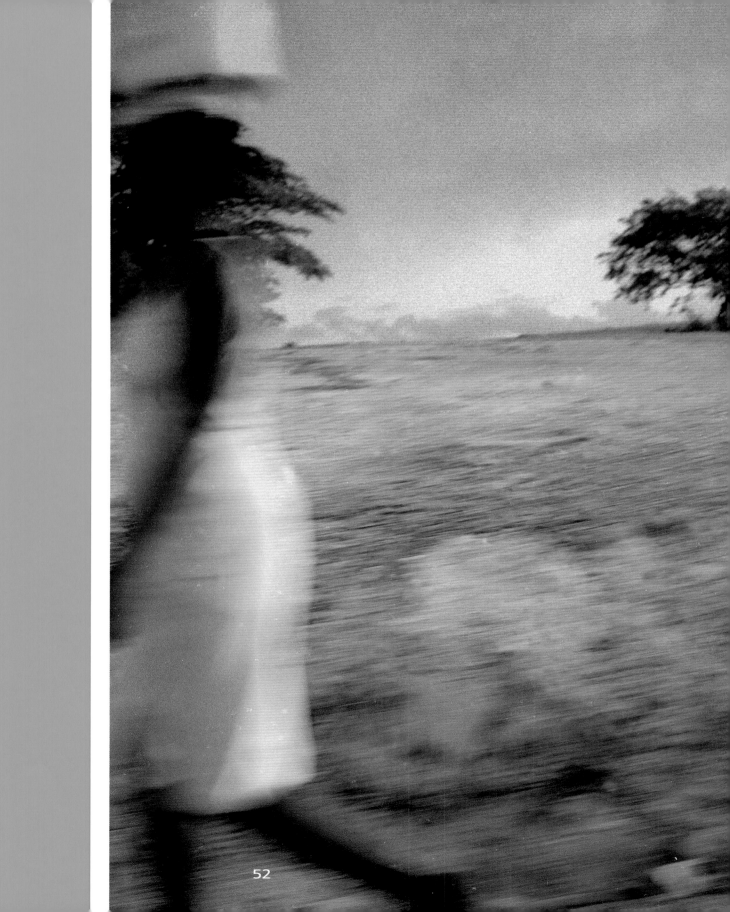

Trod on

if the load pon di bus stop

or pon mi head top

trod on

if the sun melt di tar road

or rain soak mi silk frock

trod on

it is only the beginning

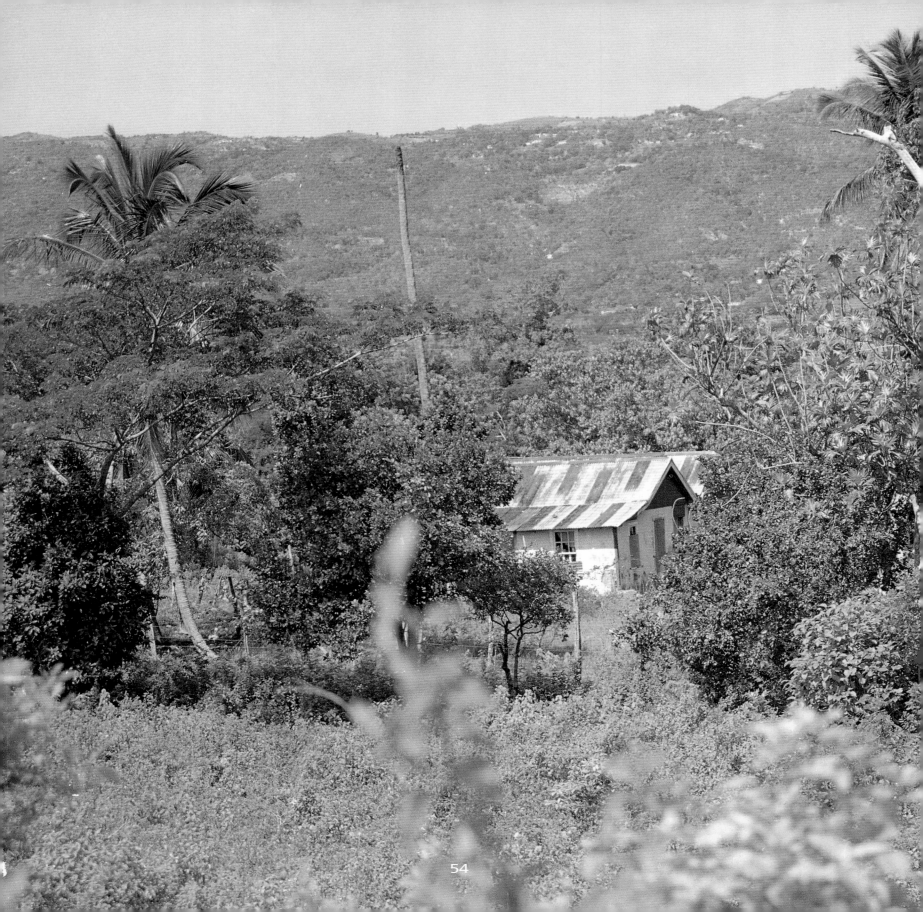

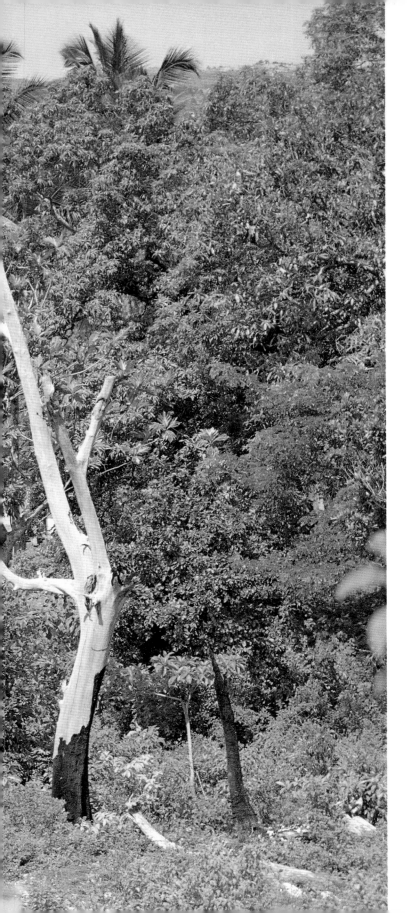

House in the Valley, Santa Cruz.

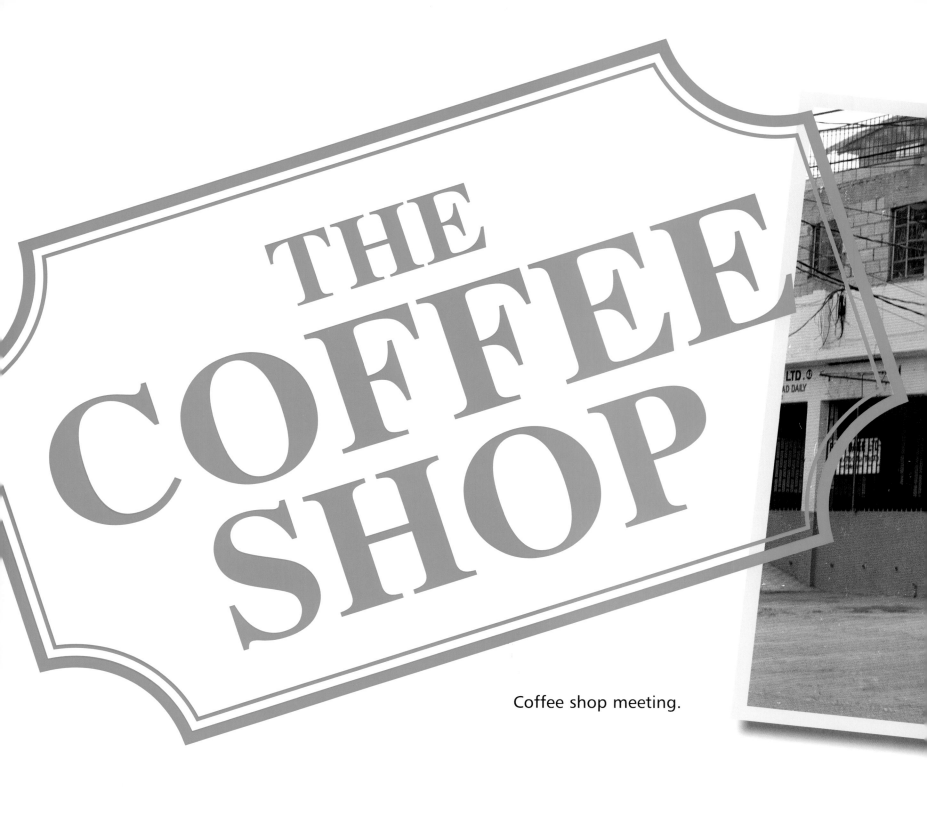

THE COFFEE SHOP

Coffee shop meeting.

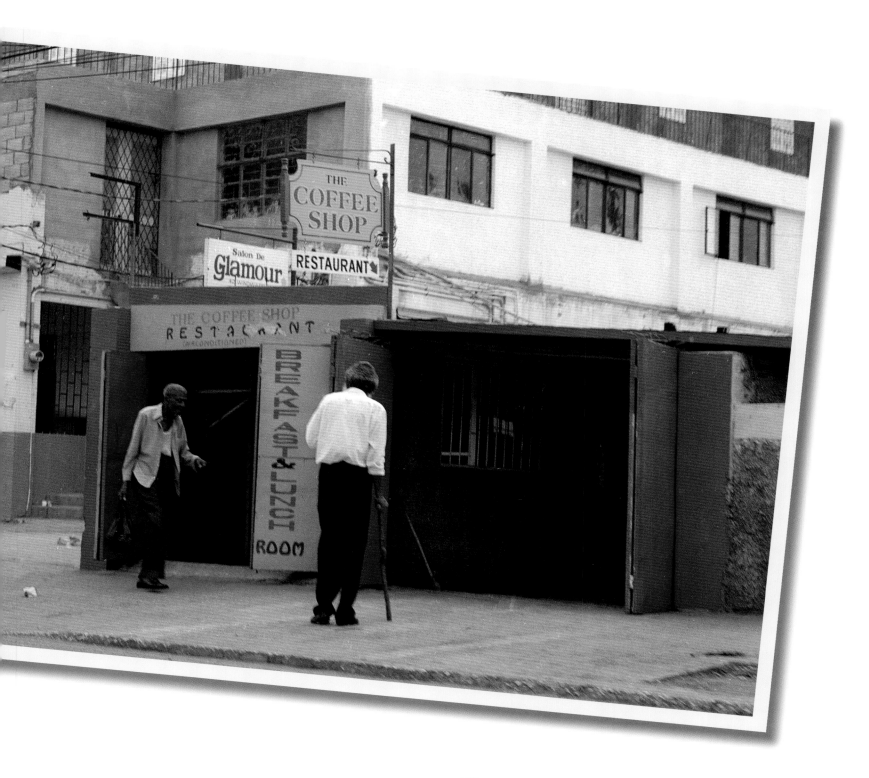

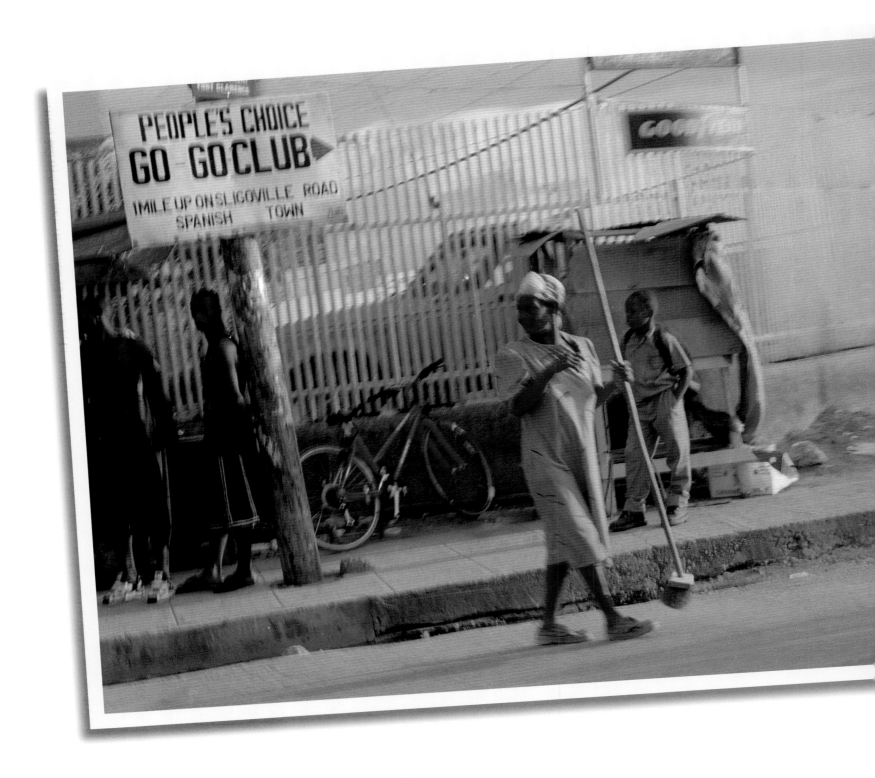

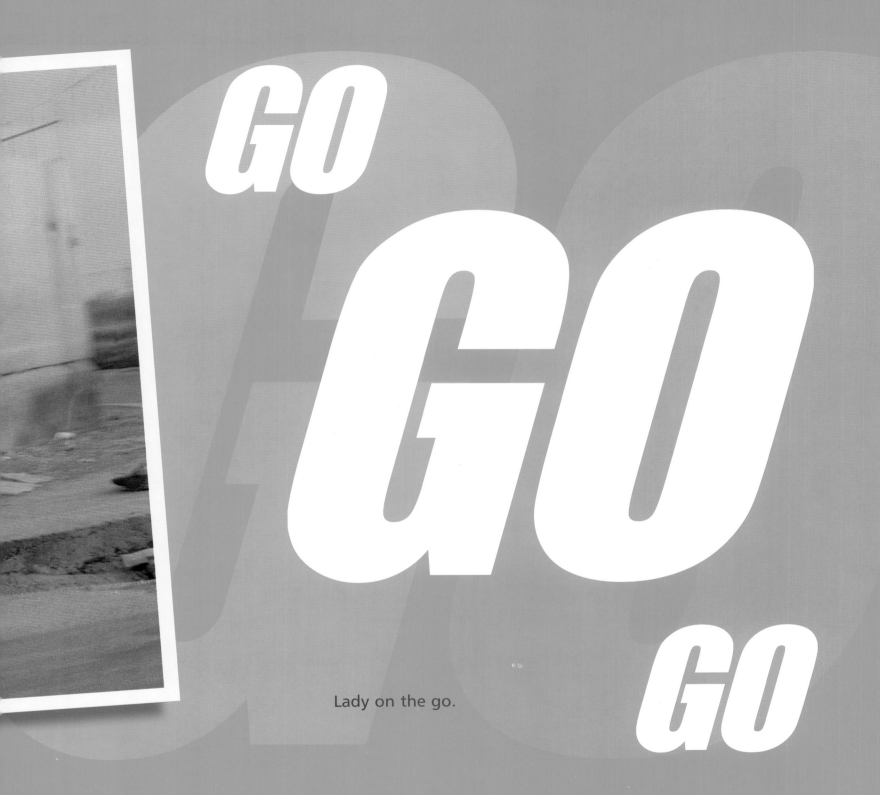

GO

GO

GO

Lady on the go.

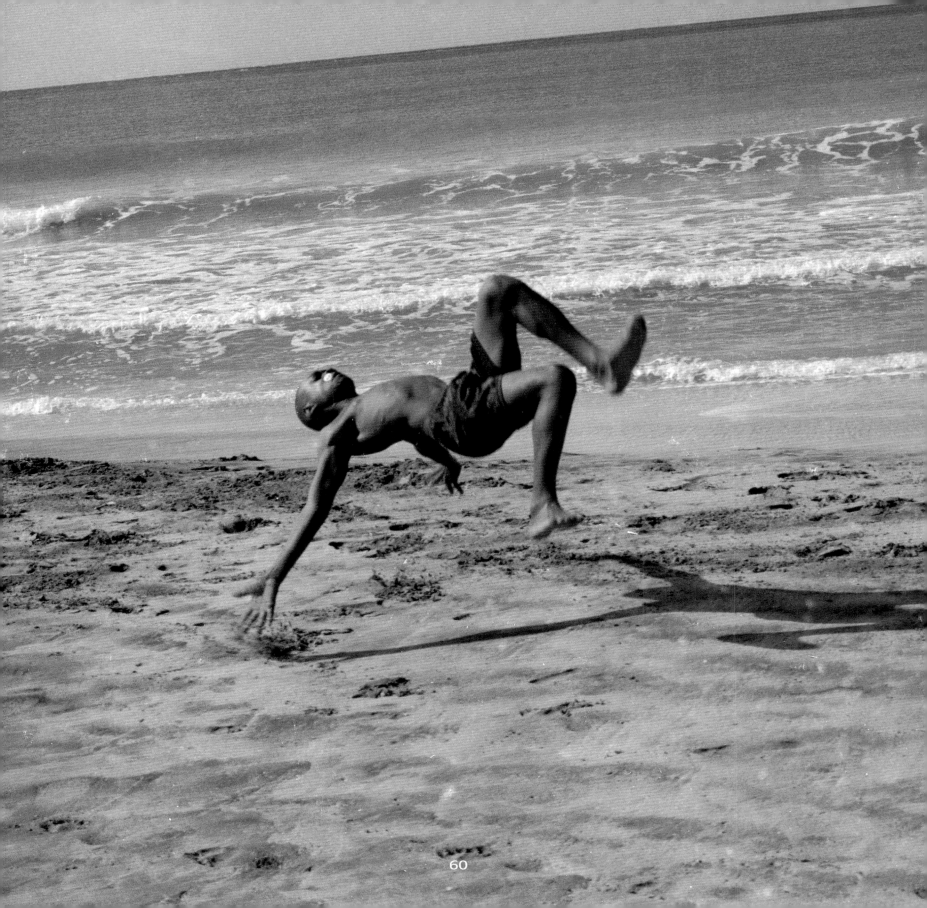

If there is no fear
and golden majesty continues to shine
the little ones must frolic about as young ponies
and glisten under its rays.

Boy on Treasure Beach.

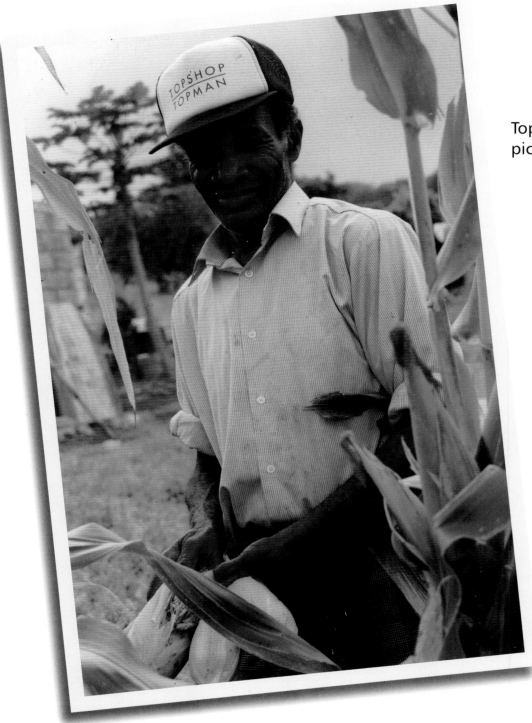

Topman - my Granduncle picking corn at Christmas.

Boy with a rod
catching black fish in the river
goes home in the hills of
 Manchester.
My friend with black
 fish in black bag
 behind him smiles
and continues along

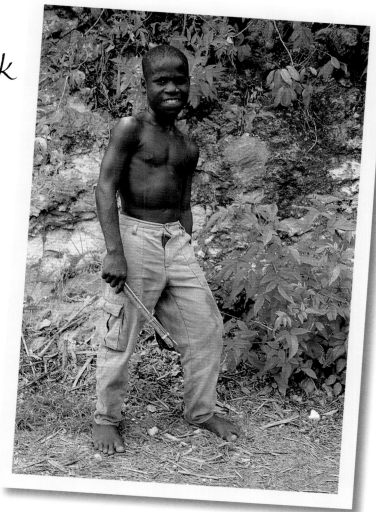

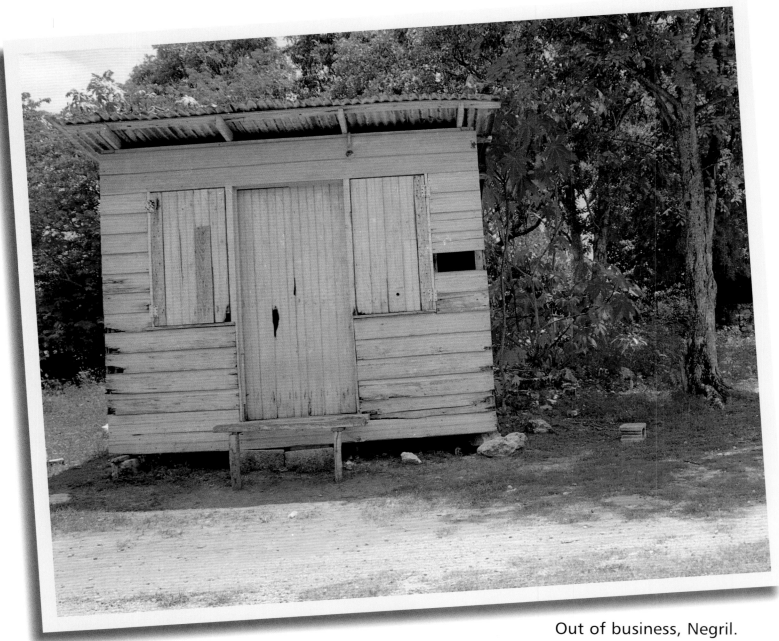

Out of business, Negril.

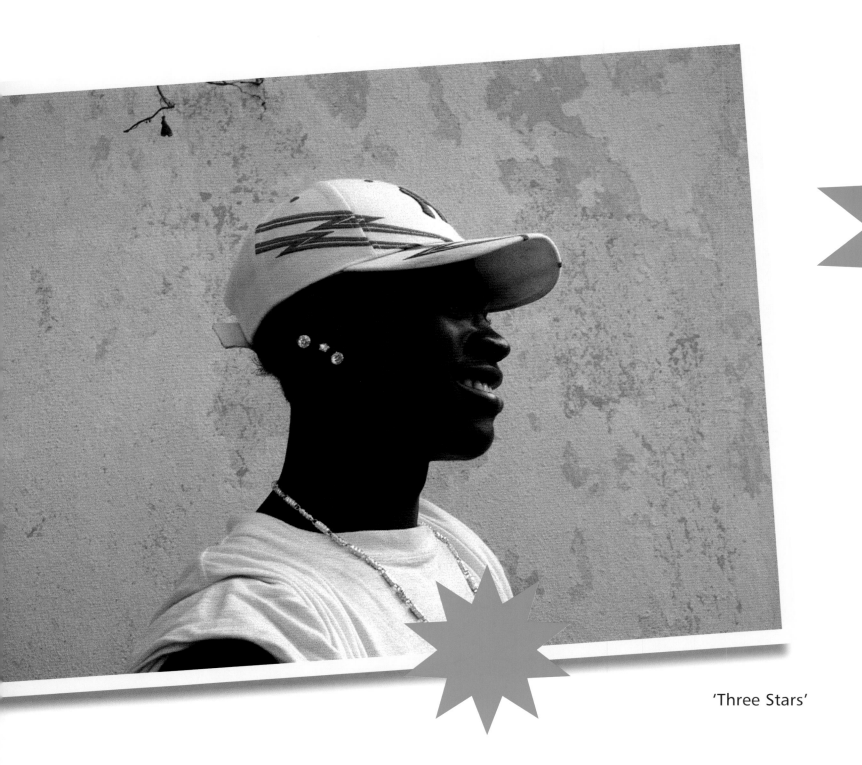

'Three Stars'

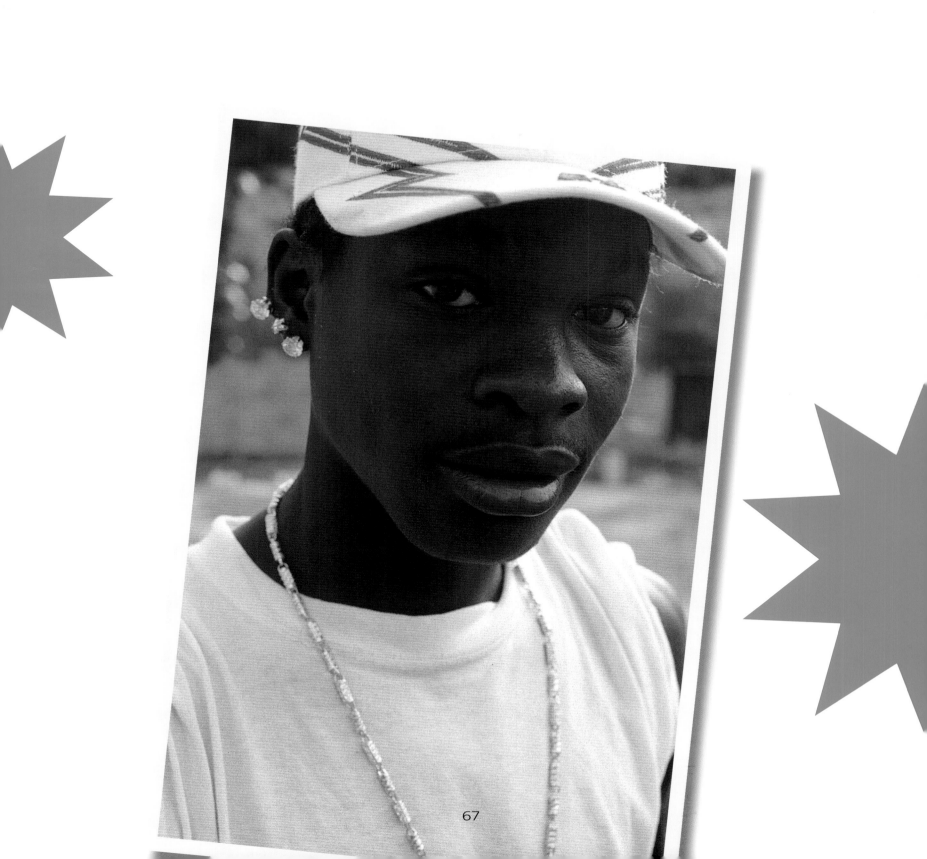

67

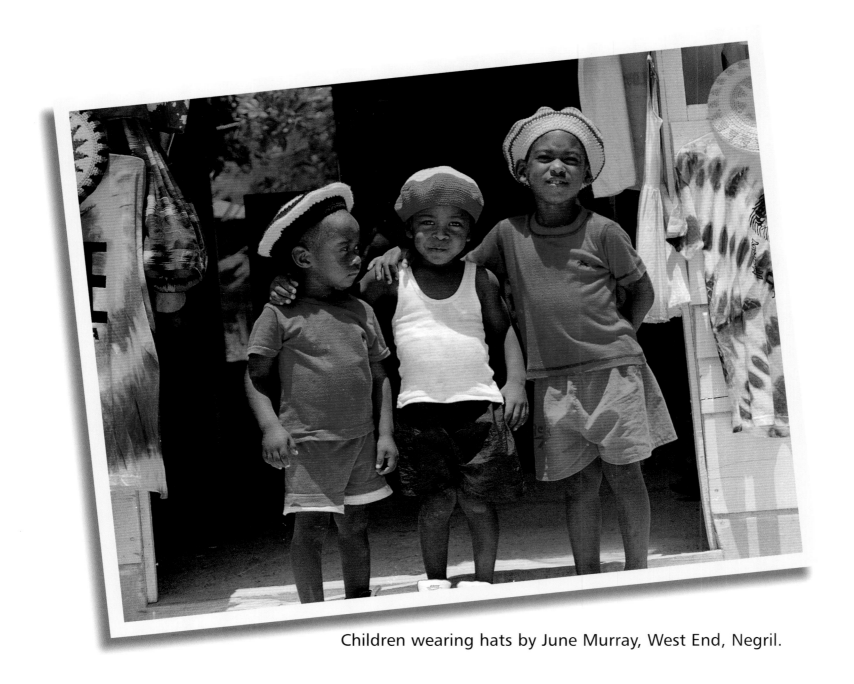

Children wearing hats by June Murray, West End, Negril.

tomorrow hope
tomorrow power
today's youth
tomorrow future

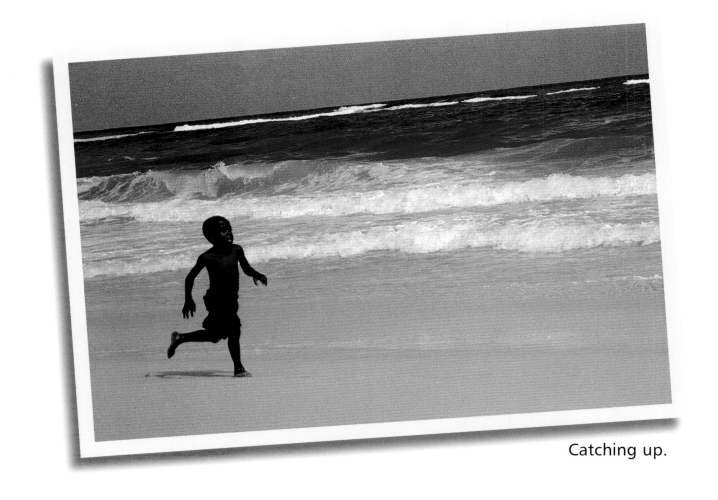

Catching up.

Through the music, through the beach, through the young ones, through the free, if only we can learn to be, Unity is You and Me...

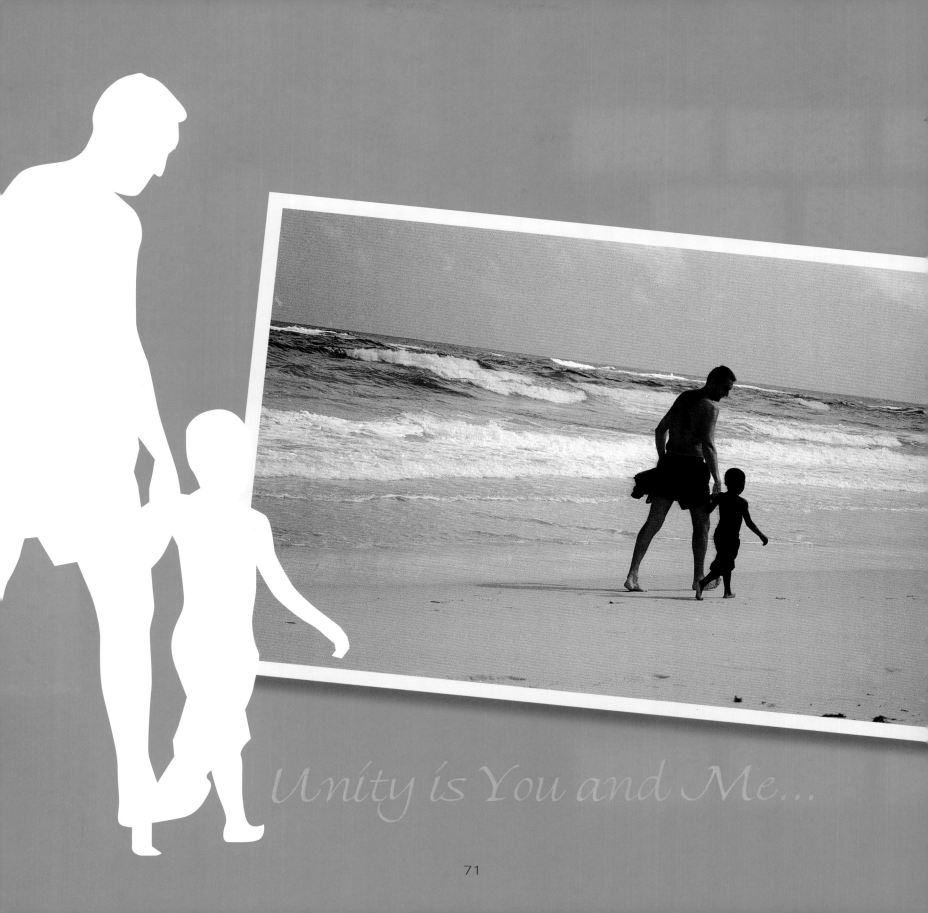

Unity is You and Me...

take me through your past
take me to school
lead me with your hands
lead me to the truth
show me a way
to the better days
take me from your past
take me and fast

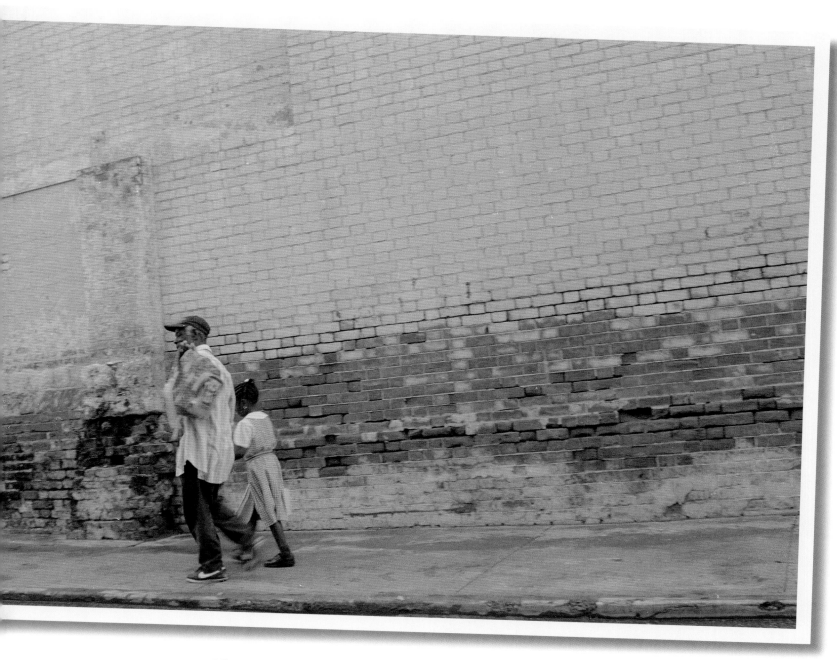

Downtown Kingston.

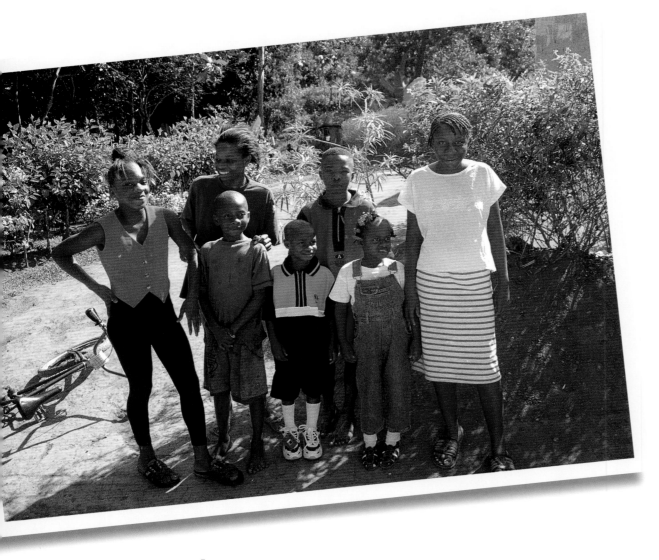

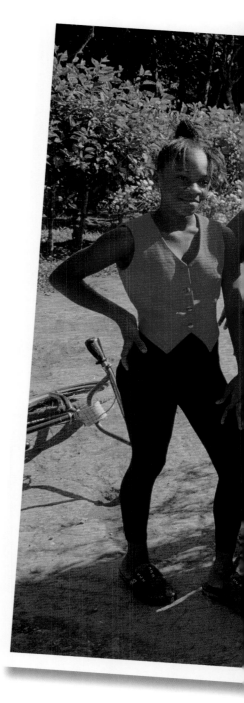

Sunday evening

is no Sunday evening without…

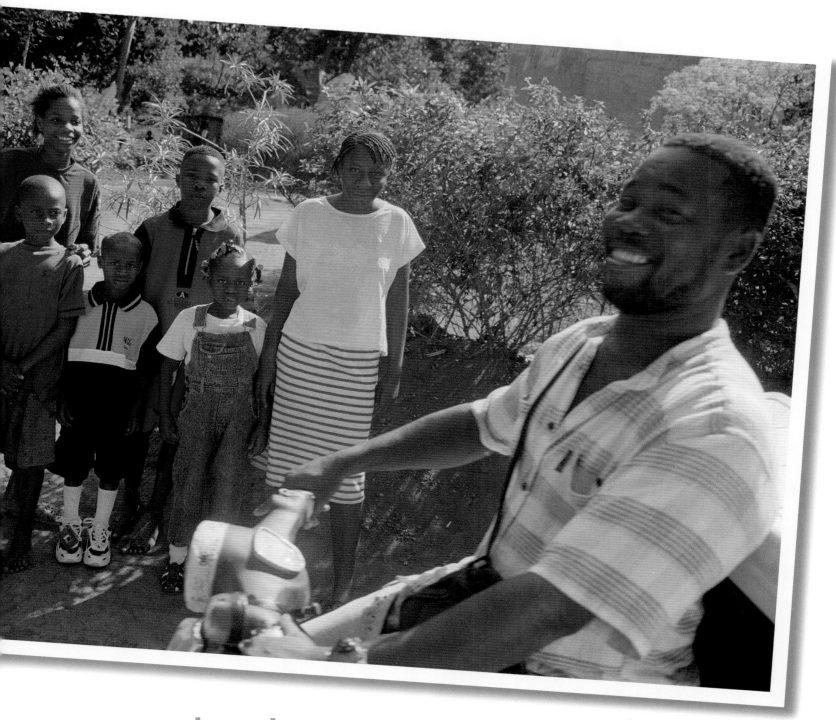

...the ice-cream man!

Rita's Snack Shop, Westmoreland.

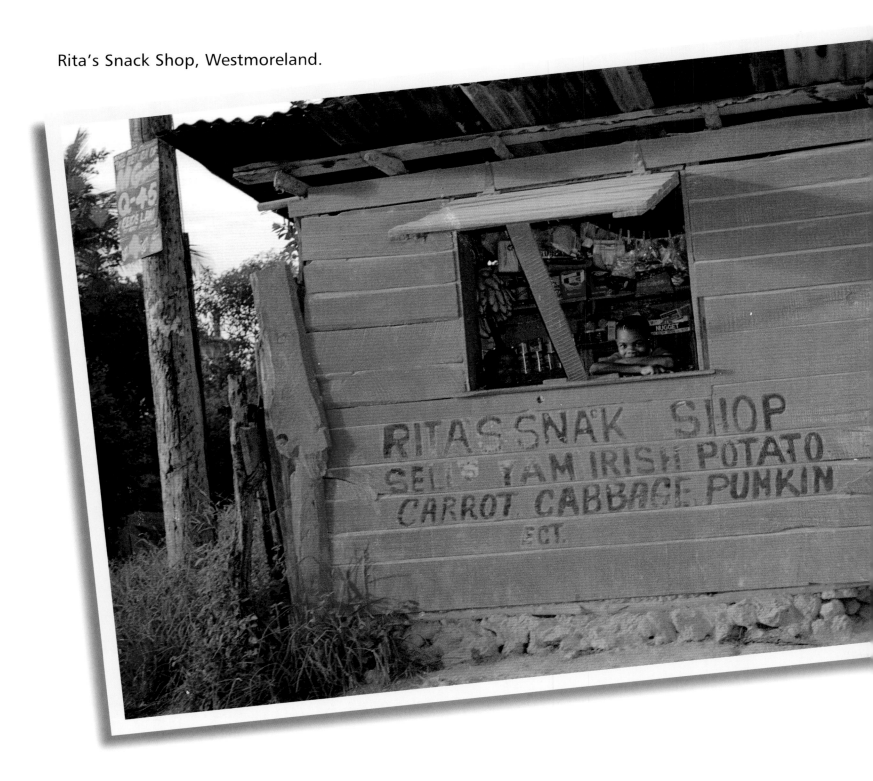

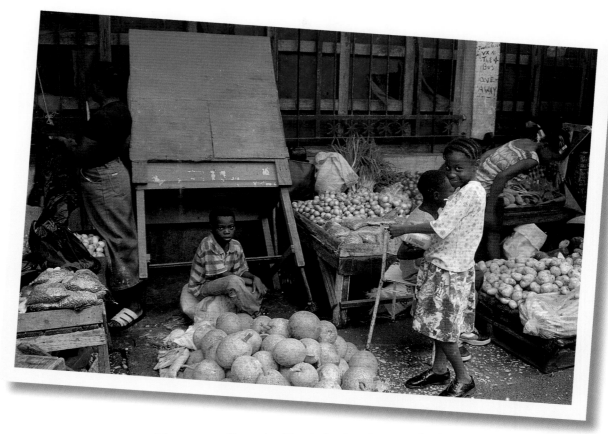

Young sellers in Port Antonio market.

breadfruit, red peas, turnip and tomato

give new shoes with some Irish potato

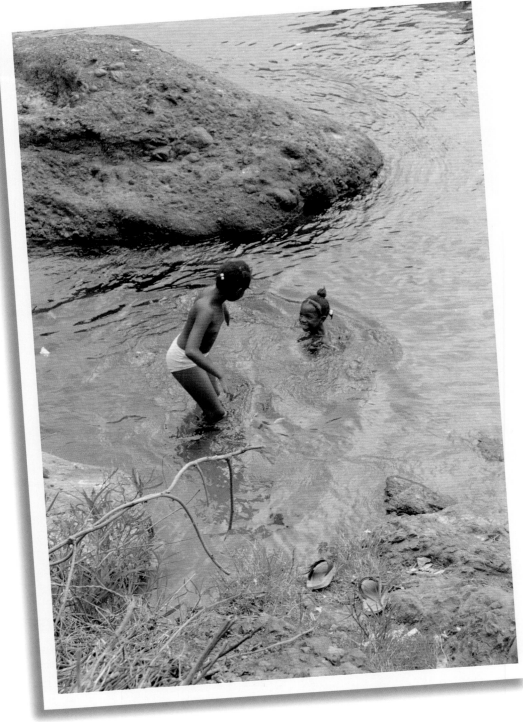

Children bathing in the river, St Mary.

Models wearing outfits by Samantha Jones (Kingston).

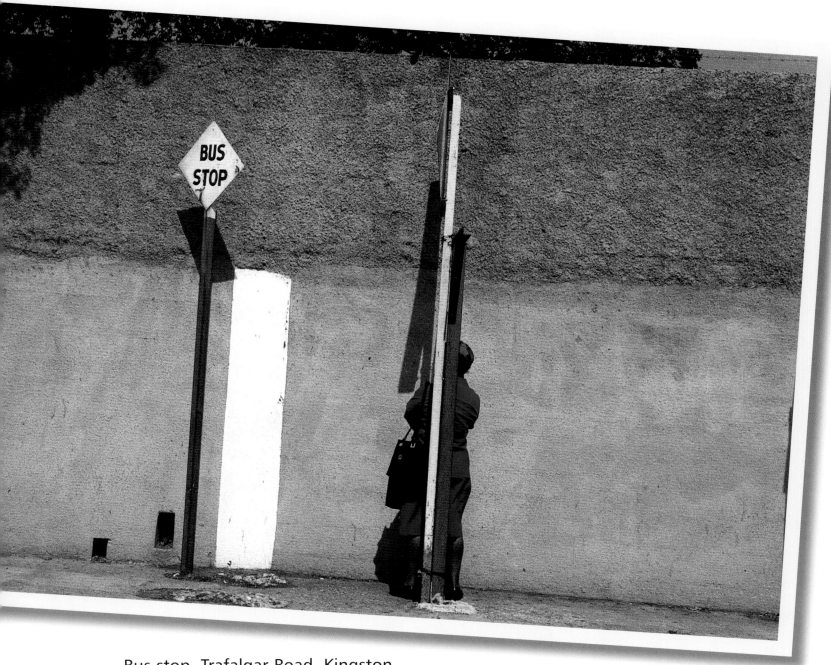

Bus stop, Trafalgar Road, Kingston.

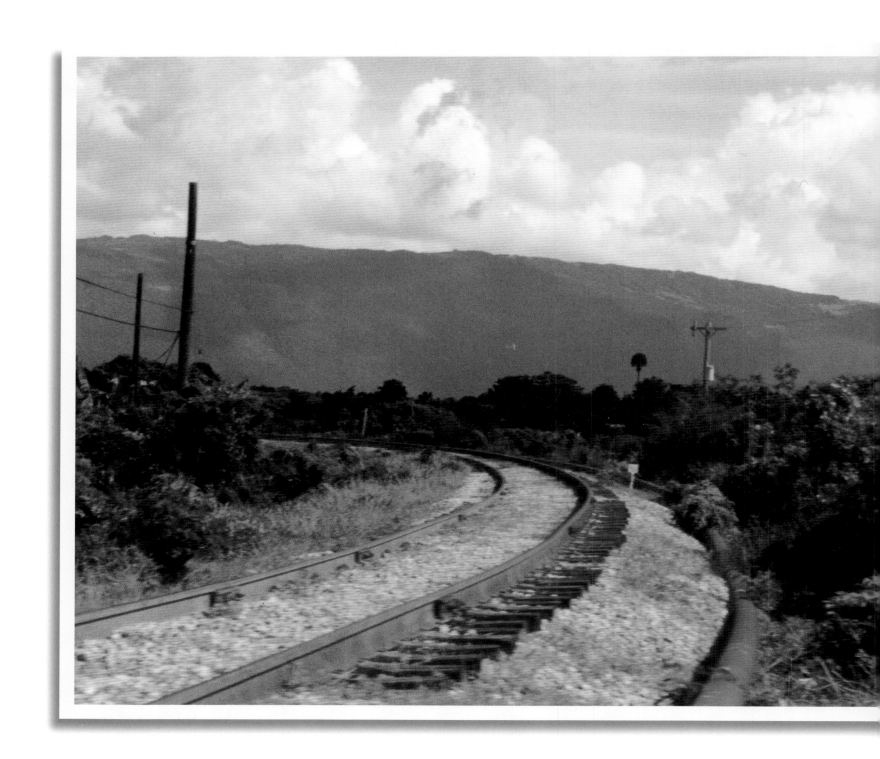

Railway taking bauxite between
Nain and Port Kaiser.

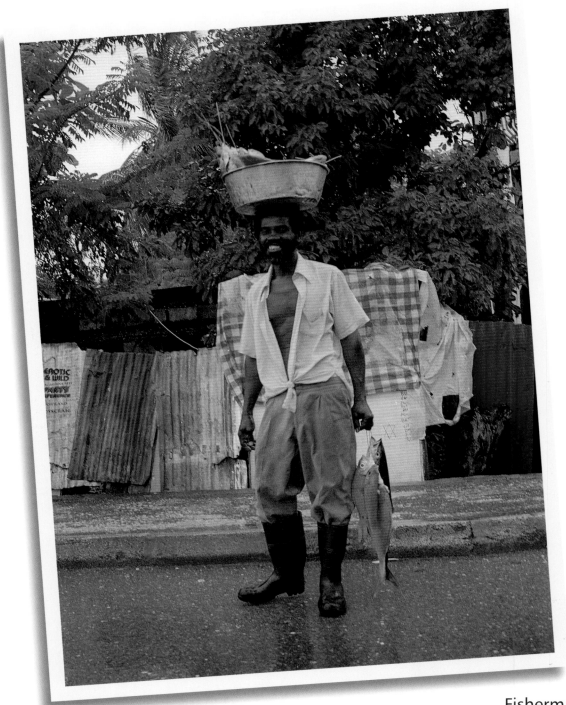

Fisherman in Port Antonio.

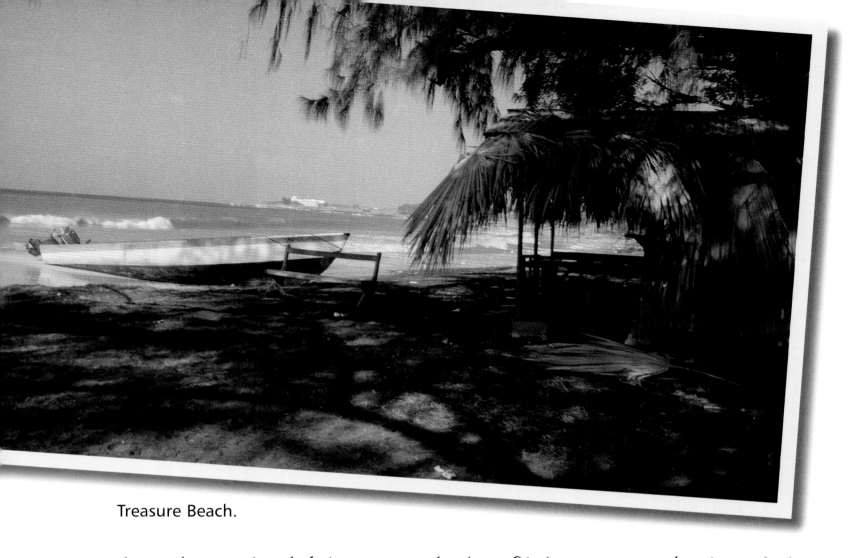

Treasure Beach.

let the wind blow and the fisherman bring his
 boat in then lay low
fold the fishing net until tomorrow when the
 tide will bring in food
to feed us all

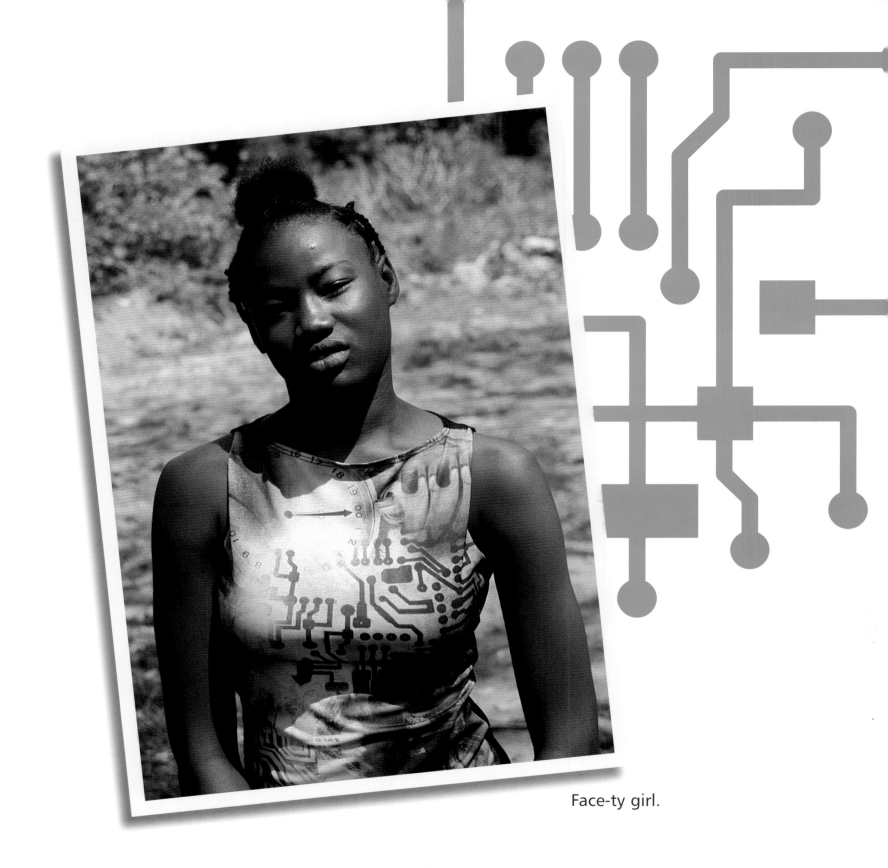

Face-ty girl.

Kid in downtown
Kingston.

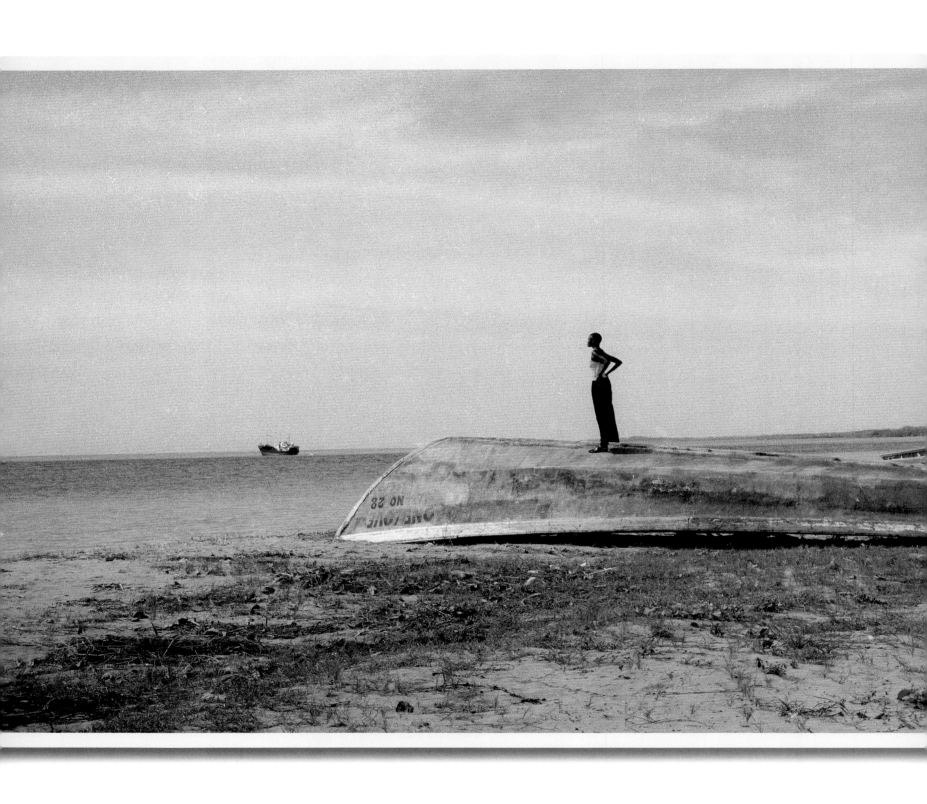

You sit on the edge of the world

You reign

You spread the skies with your anger
 and your joy

You reign

You reign in the hour

Half in this world and another

Above and beyond

You reign

Your glory, great glory

Never ending

For ever and ever

And the Lord will create upon
every dwelling place of Mount Zion,
and upon her assemblies, a cloud
and smoke by day, and the shining
of a flaming fire by night: for upon
all the glory shall be a defence.

Isaiah 4 vs. 5

Sunset in Negril at Tensing Pen.

Then...

I started this book during my short trips home for work or relaxation. I was modelling internationally and also doing my first book, **A Glow in the Dark**, which was launched in December 1999 (LMH Publishing, Jamaica).

A Glow in the Dark told the story of my life as a model. I shared some of my experiences, gave some advice on taking care of the face and body, since beauty is such an important issue in the business. Spoke of the importance of being professional in a fickle and superficial world and how essential it was for me to have spiritual strength, which helped me to be ever faithful and persistent in order to achieve success. I also shared my love for art and poetry, which can be seen throughout the colourful pages with images of myself from various magazines and catwalks from the fashion capitals of the world.

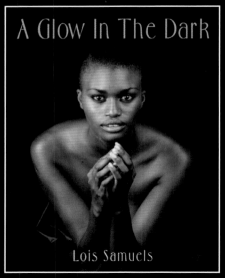

A Glow in The Dark: **LMH Publishing**

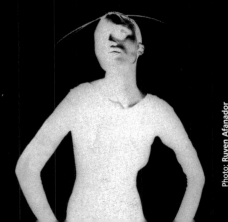

Photo: **Ruven Afanador**

92

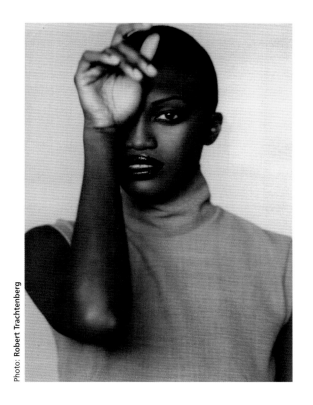

Photo: Robert Trachtenberg

When I did the first draft for this book in 2001, I was living in London and decided it was time to get a publisher. While I was browsing the Internet one day, Macmillan was one of the first publishing houses that came up. So I wrote a letter and waited. Then Nick Gillard contacted me and said that they at Macmillan Caribbean loved what they saw, which I thought was just simply fantastic!

Since that first meeting, Jamaica was home for a few months, where I had more time to capture some images of my beautiful island and enjoy the early stages of being a mother, before moving back to the States and London. I think modelling made me the kind of person who likes to live in different places and, luckily enough for me, my husband seems to enjoy the adventure as well.

...and now

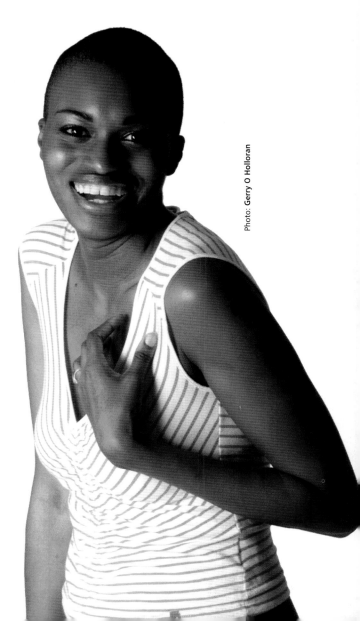

Photo: Gerry O Holloran

www.loisingledew.com

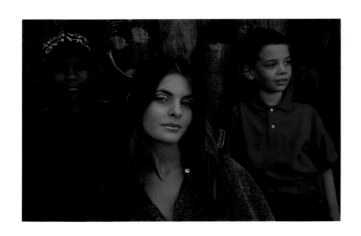

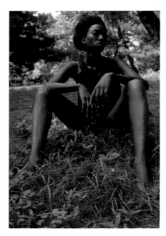

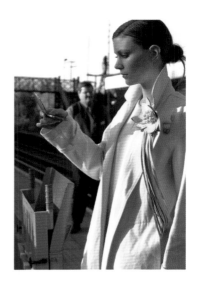

This last year I have been focusing more on fashion photography than on reportage work, working with models from some of the leading model agencies in Europe. I have also had the opportunity to have my work featured in magazines and e-zines whilst building up my portfolio (**www.loisingledew.com**). I am really enjoying it, and when I have castings to choose models for a shoot, I sometimes see that eager look in their eyes to be the one chosen, and now I wonder what photographers saw when they chose me.

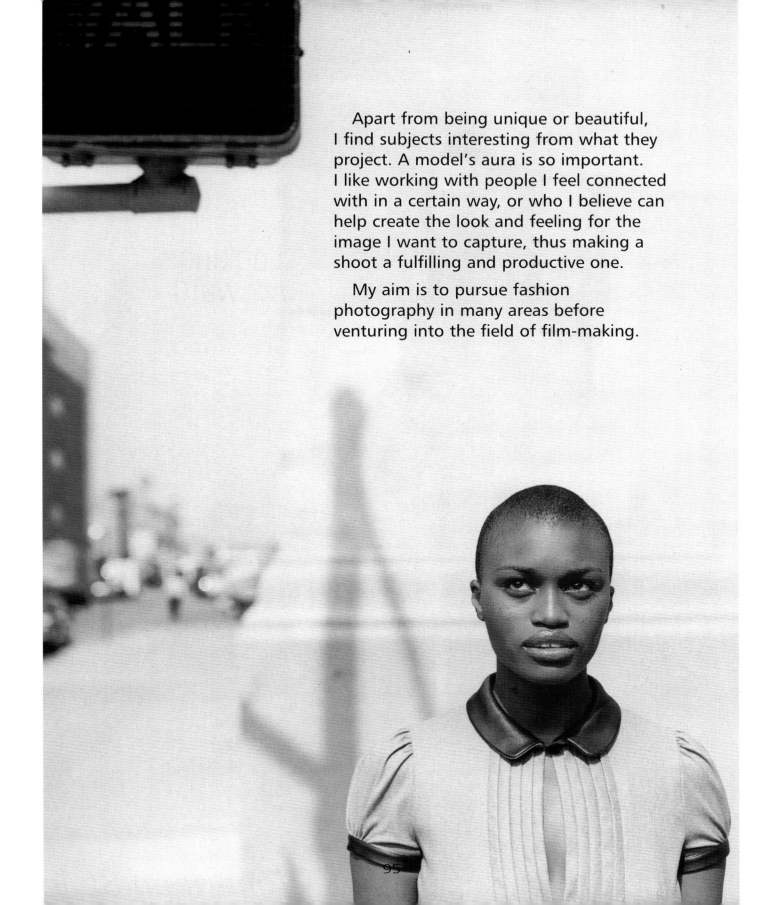

Apart from being unique or beautiful, I find subjects interesting from what they project. A model's aura is so important. I like working with people I feel connected with in a certain way, or who I believe can help create the look and feeling for the image I want to capture, thus making a shoot a fulfilling and productive one.

My aim is to pursue fashion photography in many areas before venturing into the field of film-making.

I am also working on a series of children's books with Macmillan Caribbean and wish to do another photography book on Churches of the Caribbean. There are so many different denominations and places of worship there, with different stories to tell.

But for now I am enjoying the presents of the present, being with my husband and son, being the traveller, the artist and just totally loving all the magical blessings that now gives me.

Lois

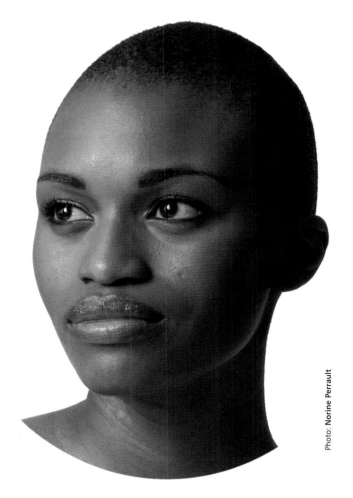

Photo: **Norine Perrault**